San Marco
FLORENCE

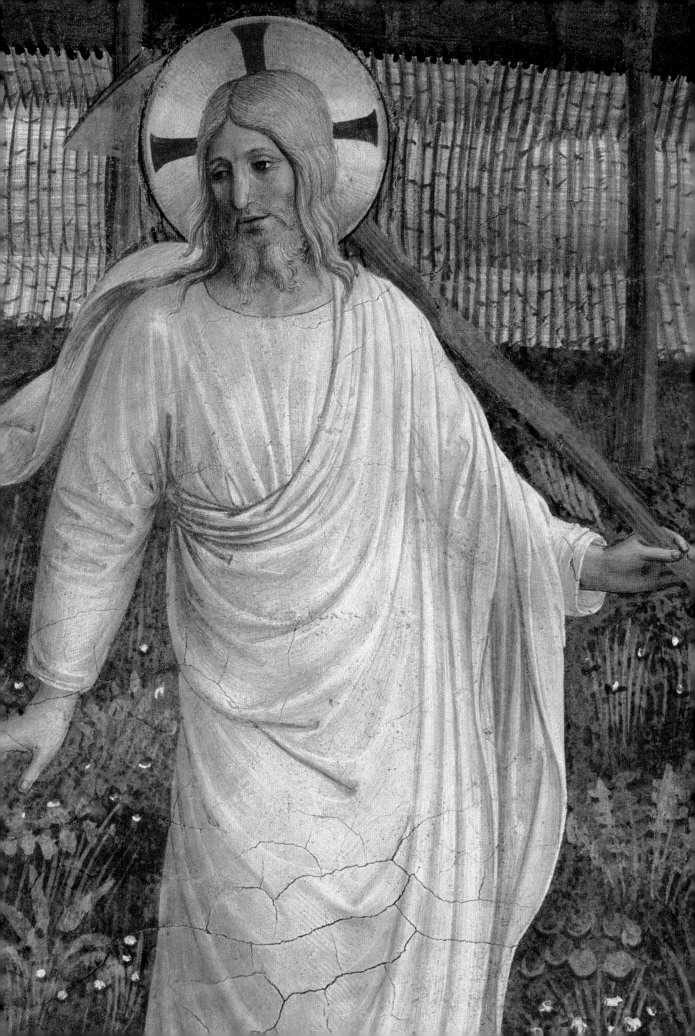

San Marco

FLORENCE

The Museum and its Art

Giovanna Damiani

Philip Wilson

Text © 1997 Giovanna Damiani
Illustrations © 1997 Philip Wilson Publishers Limited

First published in 1997 by
Philip Wilson Publishers Limited
143-149 Great Portland Street
London W1N 5FB

Distributed in the USA and Canada by
Antique Collectors' Club
Market Street Industrial Park
Wappingers' Falls
NY 12590
USA

ISBN 0 85667 474 5

Designed by Andrew Shoolbred
Photography by Marco Rabatti and Serge Domingie
Translated from the Italian by Rupert Hodson
English translation edited by Moria Johnston
Printed and bound in Italy by
Società Editoriale Libraria per azioni, Trieste

Contents

Foreword

The visitor who follows this guide to the museum of San Marco will be taken well beyond the actual boundaries of the museum itself in an encounter with many and varied aspects of Florentine culture and history which are reflected in the building and the works of art which it houses.

The long and richly complex history of the Dominican community is here knowledgeably presented through a focused and detailed examination of the architecture and the collections of artefacts. The adjacent church of San Marco and the rest of the convent (both of interest to the visitor of the museum) still belong to its famous order for whom, in the fifteenth century, Cosimo de' Medici the elder restructured and embellished the building by the work of his architect Michelozzo and that of the painter Giovanni da Fiesole, known as Beato Angelico, a friar of the order.

The vitality of this convent continued well beyond the early Renaissance, especially through the work of Fra Bartolomeo, a worthy successor in the early sixteenth century to the inheritance and tragic spiritual legacy of Fra Girolamo Savonarola and his followers. Fra Bartolomeo interpreted the devotional art tinged by the martyrdom of Savonarola and contributed splendid painting qualities which were profitably gathered up by the painters of the Scuola di San Marco.

The visitor will also be drawn to the other components which go to make up the historical and artistic wealth of the convent of San Marco: the library; Ghirlandaio's Cenacolo, which has recently been restored; the *pinacoteca* of Beato Angelico; and not least the collection of fragments salvaged from the demolition of the city centre in the nineteenth century.

The pages of the guide will provide a well balanced and ordered appreciation of the museum and a serene and thoughtful visit for those who, on leaving the crowded and noisy streets, enter the peaceful world of the cloisters of San Marco.

CRISTINA ACIDINI
Soprintendente Vicario

Introduction

Situated at the northernmost edge of the ancient city centre, the San Marco Museum is in an area which, since the Middle Ages, has been rich in monumental buildings of historic, social and religious interest. There were not only many monasteries founded in this area leading down to the Porta San Gallo, but also numerous hospitals such as San Bonfazio and San Matteo, just to give two examples of buildings that have been radically altered. The San Marco Museum is one of the most frequently visited museums of the city, even though it is not one of the largest, and the singularity of its nature has meant that, although it is only a few steps from the Galleria dell'Accademia, it has been excluded from the modern phenomenon of mass tourism. Because of this the visitor to San Marco is rather special. He or she has chosen to cross the threshold in order consciously to share in a spiritual and cultural atmosphere that has remained unchanged over centuries, unaffected by the vicissitudes of historical events and its own internal transformations. Even today that atmosphere pervades the rooms, and the hubbub of the daily life of the city is left behind at the ancient entrance door.

The uniqueness of San Marco lies in the centuries-old close connection between the building itself – still today fully recognizable as monastic in form – and the works it contains; works that in some cases were specifically commissioned for the building, and others that came from different places belonging to the Dominican Order. Furthermore, the measures that have changed it into a museum after its original transformation, have progressively contributed to the enrichment and coherence of the cultural heritage offered to scholars and visitors alike. San Marco is closely tied to the historical, political and religious events of Renaissance Florence and to the distinguished individuals who lived, worked or preached there, from St Antonino to Michelozzo and Fra Angelico, from Girolamo Savonarola to Fra Bartolomeo and, in recent times, Giorgio La Pira, mayor of Florence in the 1960s. From the beginning these people have been intimately interwoven with the structure of the building and their memory has been kept alive by their artistic achievements.

The Museum of San Marco was founded in the oldest and most historic quarters of the Dominican Monastery of San Marco, which had passed into state ownership in 1866 following the suppression of the monasteries and which was, at the same time, declared a national monument. It was dedicated to the memory of illustrious members of the Dominican Order and opened to the public in 1869.

The architectural complex of the monastery was thus divided, allowing the Dominican monks, even to this day, the use of the more recent buildings and those areas that were only partially affected by the reconstruction and enlargement carried out by Michelozzo di Bartolomeo, the preferred Medici architect, between c.1436 and 1444. Michelozzo built over an original structure that had belonged to the Silvestrine monks, a reforming branch of the Benedictine Order

instituted by Silvestro Gozzolini and founded at the end of the thirteenth century. This order, after a long and distressing saga culminating in the loss of their ancient status, was exiled to the Florentine Church of San Giorgio della Costa and was replaced, with the direct intervention of Cosimo il Vecchio de' Medici, by Dominicans from the monastery at Fiesole. Cosimo then prepared to restore the ancient buildings, which were recorded as being in ruins, and entrusted the task to Michelozzo. Recent findings of wall paintings beneath the actual floor level in some areas facing Piazza San Marco, and on the walls that today still border the large area that would become the Hospice of the Dominican monastery, reveal the full scope of the work carried out by the Medici architect. He did not attempt radical reconstruction by knocking down the ancient buildings, as had been thought by art historians, but restored and enlarged what at the time must have already been one of the more important medieval monasteries in Florence.

In fact, as well as the adjacent Church and Refectory, and the small Cloister named after the Silvestrines which was known to have formed part of the original buildings, even the large area facing Piazza San Marco now appears to have been within the ancient boundaries of the old monastery that Michelozzo incorporated and raised in height. With the XV century restoration he conferred on the buildings, however, a sense of order and spatial clarity, typical of his skill in establishing translucence and linearity, which is best expressed, on the ground floor, by the two great cloisters. One of these is dedicated to St Antonino and is reached from Piazza San Marco, and the larger one, named after St Dominic, is still used by the Dominican monks and does not form part of the Museum complex. Many of the rooms in these cloisters, which were designed for the collective life of the Dominican community and for service areas, such as the kitchen and the so-called Corte del Granaio or the Chiostro della Spesa and the ancient Foresteria (guest quarters) with its connecting Small Refectory, which were documented in the past or survive in the current layout, are still recognizable because they were not substantially altered by successive restorations.

On the first floor Michelozzo built dormitories, along three corridors, and the Library, designed like a basilica, which became a model for this type of room in Renaissance architecture because of the purity of its lines and its harmonious and measured spatial elegance. Cosimo de' Medici himself endowed it with valuable codices in Italian, Latin and Greek that had, for the most part, belonged to the humanist Niccolò Niccoli, and it became the first Italian library to open to the public.

Starting in 1437, Fra Angelico began to paint in fresco in the 43 cells leading off the corridors episodes from the Life of Christ, one for each cell, with the assistance of a prolific and homogenous workshop, and with whose help the painter-monk combined a renewal of the Renaissance idiom with the spirituality of the Catholic faith.

The entire monastery complex took on the form of a well-constructed, modern organism, rationally thought out to satisfy the material and spiritual needs of the community that lived there and enhanced by extensive vegetable gardens by its northern boundary; and at the same time it contained in embryo all the characteristics that

could be defined as being almost natural to a museum, even to a museum of itself, as it was to become.

The successive enlargements and alterations that took place after Michelozzo did not substantially alter its original aspect; they were geared to increasing the functionality of the existing structure to meet the changing needs of the monastic community, or they involved alterations to the decorative scheme to meet commemorative requirements in keeping with the tastes and necessities of the time.

It was at the beginning of the eighteenth century that the first plan to create a museum within the monastery was suggested. Initiated to some degree by the Dominican community itself, the scheme was dedicated to another artistic eminence of the order, Fra Bartolomeo, a sixteenth-century painter-monk of San Marco, just as Fra Angelico had been 50 years before him. The latter's works had been of particular interest to the Medici family, who had always been great patrons of the monastery, even though it had given birth to and fostered the fiercest opposition to their rule in the person of Savonarola. Interest in Fra Angelico was at its height in the eighteenth century when various members of the Medici family acquired a series of important paintings that had been in the Church of San Marco. Almost as if to compensate for this loss, the Dominicans assembled a collection of Fra Bartolomeo's paintings that partly came from the Church of San Marco but mostly from the Ospizio della Maddalena in Pian di Mugnone, a dependent branch of the San Marco Monastery, where the monk had worked and lived over long periods and where he died in 1517. The collection, with the explicit connotations of a proper *pinacoteca*, was housed in the

Fra Angelico
The crowning of the Virgin
Detail, Dormitories, first corridor

first three cells which functioned as an oratory and which had been occupied by Savonarola. These were situated at the end of the second (south) corridor of the dormitories, known as the "Giovanato" (Fra Angelico was also known as Fra Giovanni). The choice of their location emblematically underlined the close connection of Fra Bartolomeo with the preacher from Ferrara, whose artistic ideals he interpreted and who influenced his spiritual life.

The Fra Bartolomeo picture gallery that had been established in the chapel of the Giovanato was dismantled following the Napoleonic suppressions of 1810, and the paintings were dispersed at the same time as the other movable works of art that had belonged to the Monastery. After the unification of Italy and the government suppressions in 1866 it became almost a foregone conclusion that the Monastery of San Marco would become a museum, since the prestigious complex was richly endowed with objects of religious and cultural significance which were still appropriate because of the spiritual, cultural and political history of Florence. Already, twenty years before, studies done on Fra Bartolomeo by Padre Vincenzo Marchese and the publication in Paris in 1855 of an illustrated edition of Fra Angelico had substantially contributed to a revaluation of the most important achievements of those artists who had furnished the Monastery with their finest works. But it was only with the opening of the Museum in 1869 that the most significant cycle of Fra Angelico's frescoes emerged from the seclusion of the closed Monastery, where for so many centuries they had been. So inaccessible had they been that even Vasari was unable to give them adequate prominence.

When the public was allowed access to the Museum in 1869, only those rooms that had best preserved their original characteristics were opened. These were on the first floor, including the Library, and, on the ground floor, including the two great cloisters, the Chapter House and the Refectory. These were restored by the architect Mazzei, and Fra Angelico's frescoes, almost a natural picture gallery, were skilfully restored by Gaetano Bianchi. In the Library, especially constructed display cases showed a choice selection of illuminated choir books that had been assembled in San Marco after the suppression of the monasties of 1866, and that had, in part, originated in San Marco itself, like the series made by Zanobi Strozzi for Cosimo il Vecchio. Others had come from similarly suppressed monasteries both in the city and the surrounding area. They amounted to more than one hundred codices which since that time to the present day have been kept in the large eighteenth-century cupboards in the Sala Greca, or Greek Room, and are displayed in the Library in rotation.

The establishment of a museum in San Marco had been one of the priorities of the Risorgimento. The reinstatement of the significance of Savonarola, who personified religious, ethical and political virtue, was thought to be especially pertinent. The aims supporting these active plans were shared by a large group of liberal Catholics who wished to connect the Vatican state to the newly formed Italian state. Savonarola's cells were thus again the object of attention, and it is in this light that some alterations, connected with the cult of the preacher from Ferrara, can be justified. Alongside the relics that had been collect-

ed over the years (in some cases with the assistance of private citizens), attempts were made to locate works by Fra Bartolomeo, who had been a fervent follower, and a small collection of his paintings was assembled during the 1870s. Among these was his famous portrait of Savonarola which is still here. Then, as had happened in the eighteenth century, a few frescoes from among the small number which were still available either in the Monastery of San Marco or in the subsidiary Monastery of Santa Maria Maddalena alle Caldine were added to the collection. Where the altar had stood, the great cenotaph of Savonarola by Giovanni Duprè was placed. In the same way and in the same vein of honouring those notables whose own history was tied to the history of the Monastery, the cells of St Antonino and Cosimo il Vecchio de' Medici were refurnished, and relics and mementos that exalted them were put on display.

Once the idealism of the Risorgimento had faded – and with it the underlying commemorative motivation – and had been replaced by positivist thinking, the Museum of San Marco came near to closure. After twenty years of controversy there emerged the idea of improving the Museum by adding paintings kept in the city's repositories where they had been assembled following governmental suppressions. This end was partially achieved. Starting in 1894, Guido Carocci, then the director of the Museum, began collecting stone remains from the old Florentine city centre, an urban area that corresponded to the perimeter of the old Castrum Romano and one rich in historical deposits tied to the development of the medieval city.

Today, these stones represent all that survives of the medieval nucleus of Florence: "a pathetic inventory of bones", as they were described by Adolfo Venturi in 1911. All that was thought worthy of preservation, from that massive treasury of historic buildings, palaces, churches, houses and artisans' workshops demolished during the last two decades of the nineteenth century, amounted to this. Until then these buildings had survived intact; now they were destroyed to make way for the "re-sanitation and re-ordering" of the historic city centre, despite considerable opposition from more enlightened opinion, both national and international.

The fragments of architectural decoration and frescoes were catalogued and classified in the cloister of St. Dominic and in the Antica Foresteria, and so these collections became a real "sampler" of decorative elements whose function was representative and educational. They gave rise to a distinct section of the Museum, which became known as the "Museum of Old Florence", inaugurated officially on 28 April 1898, though work on it was only finished in 1904. These fragments were added to the collection of family coats of arms and tomb inscriptions that had come from the ancient Monastery of San Pancrazio and were transferred to San Marco in 1894 and mounted on the south wall of the Cloister of St Dominic.

The collection was further enlarged up to 1915, but during the 1920s loss of interest in museum stone collections led to neglect of this section of the Museum, which was relegated to the role of a depository, used to complete or refurbish collections in other city museums. Only recently, in 1990, has the collection of fragments from the old city

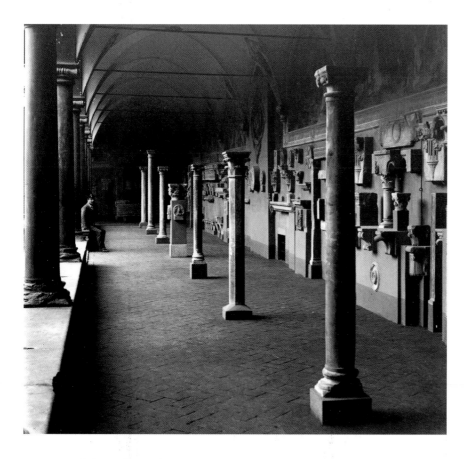

San Marco Museum, Florence
Cloister of St. Dominic

Fragments saved from the demolitions of the historic centre of Florence, in the original setting by Guido Carocci.

centre and those from the graveyard at San Pancrazio become the object of careful reconsideration and revaluation from the point of view of a museum. As a result of the flood of 1966, those fragments kept in the Cloister of St Dominic were removed and displayed in the basement and cleaned and restored. They can now be seen on request.

During the course of the present century further and important works have been undertaken in order to realize the full potential of the Fra Angelico collection. This coincided with the foundation of the gallery dedicated to the painter, in the period immediately after World War II; San Marco provided a natural site for this institution that since Angelico's times has been dominated by the important cycle of frescos in the dormitories. The idea of establishing this museum had been previously planned with great determination by Carocci, but only realized many years later by Giovanni Poggi, then Soprintendente ai Musei e alle Gallerie Fiorentini as well as the director of the Museum of San Marco. In the first instance he set about the restoration of the Hospice that had, until 1917, been partitioned into several rooms so that it could accommodate all the paintings by Fra Angelico that were kept in the various city museums (with the exception of some significant examples that remained in the Uffizi). The project was completed by 1921 and created the richest permanent collection of panel paintings by Fra Angelico.

The 1955 exhibition devoted to the artist's work contributed to establishing the Museum of San Marco as the Museum of Fra Angelico. It was also the occasion for further alterations, above all in the Library where the original layout was reinstated by re-aligning the eighteenth-

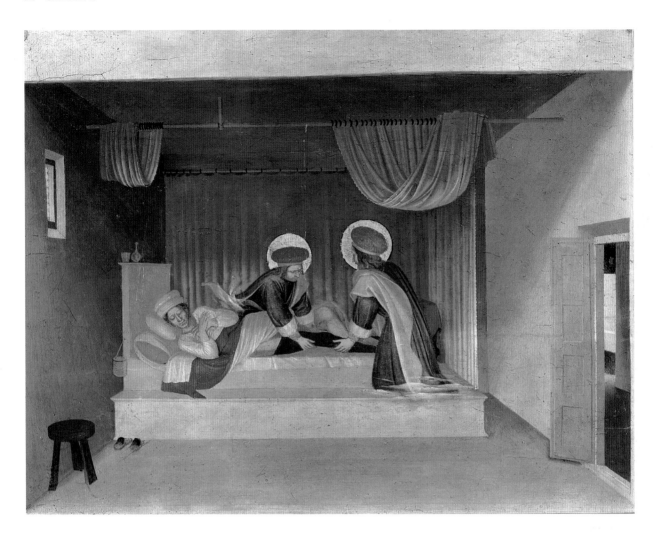

century bookcases and by replacing the nineteenth-century glass fronts
with modern substitutes (recently modified to guarantee improved and
more appropriate conservation).

The most recent exhibition dedicated to Fra Bartolomeo, has provided
the opportunity for a critical reappraisal of the artist's work and his
workshop at San Marco, which flourished during the first decades of
the sixteenth century. The workshop became a place where artistic
conventions developed explicit devotional connotations within a
framework of muted Classicism. It was unaffected by the emerging
Mannerism and finally converged with the growth of Counter-
Reformation painting.

 The great room, which was once the Monastery's large Refectory, is
dominated by the fresco painted by Sogliani in 1536. This fresco was
the end, chronologically speaking, of the so-called School of San Marco
within the complex that had housed it.

 Today's tour of the Museum encompasses the historic areas of the
ancient monastic settlement, restored and arranged so as to make the
most of every moment of the complex spiritual, historic and cultural
past of the Order which was so indissolubly interwoven with the past of
the city, its institutions and the Florentine people.

Fra Angelico
Healing of the Deacon Justian

Detail from the predella: (San
Marco alterpiece) The Pilgrims'
Hospiece

The Entrance Hall and Cloister of St Antonino

The Museum is reached through the old doorway on Piazza San Marco, via an entrance hall dominated by imposing eighteenth-century funerary monuments.

Through the austere entrance hall is the great thirteenth-century Cloister of St Antonino, one of the most evocative architectural achievements of the Florentine Renaissance by reason of its elegance and the balance of its proportions. The transition from the narrow entrance hall to the open space of the Cloister not only leads physically into the interior of the Museum complex but also, metaphorically, into the atmosphere of spirituality and mysticism which – even at a distance of centuries and despite historical changes – still breathes through San Marco.

The present form of the Cloister is attributable to the reconstruction work carried out on the monastic buildings when they passed to the Dominican Order in 1436. This work was undertaken by the architect Michelozzo di Bartolomeo (1396–1472), beginning, it seems, in 1436, at the behest of Lorenzo and Cosimo de' Medici. The Cloister was built inside the original medieval perimeter walls by constructing on all four sides a series of arches supported by elegant Ionic columns resting on a skirting which is a modern reconstruction. Leading off the Cloister on the ground floor are all the offices of the ancient monastery, most of which can still be identified. Overlooking it, on three sides, are the cells of the first-floor dormitories. The four corridors of the Cloister, spanned with ribbed cross-vaults, were originally decorated with frescoes by Fra Giovanni da Fiesole (c.1395–1455), whose lay name had been Guido da Pietro before he took holy orders in the monastery at Fiesole. He was already known as "Angelico" in the fifteenth century and is today better known as Beato Angelico or Fra Angelico.

The five frescoed lunettes above the access doors to the offices, which have been largely overlooked by scholars partly because of their poor state of preservation, are in fact of considerable importance. They are *exempla* and a reminder of the Dominican rule and doctrine, and they are thematically linked to the rooms to which the doors beneath give access. Thus, for example, underneath the first colonnade, painted above the door that leads into the Church (now separated from the Museum) is a *St Peter Martyr* cautioning silence, who not only recalls the Dominican rule, but also invites anyone who crosses the threshold to enter the Church to observe that precept. On the end wall of the first corridor backing on to the right-hand side of the Church, opposite the entrance of the Museum, is the great Angelico fresco of *Christ on the Cross adored by St Dominic*, which greets visitors as they enter the Cloister.

Later, starting in 1602, began the decoration of the internal lunettes along the perimeter walls of the Cloister depicting *Episodes from the Life of St Antonino*, which set out to celebrate the life of Antonino Pierozzi

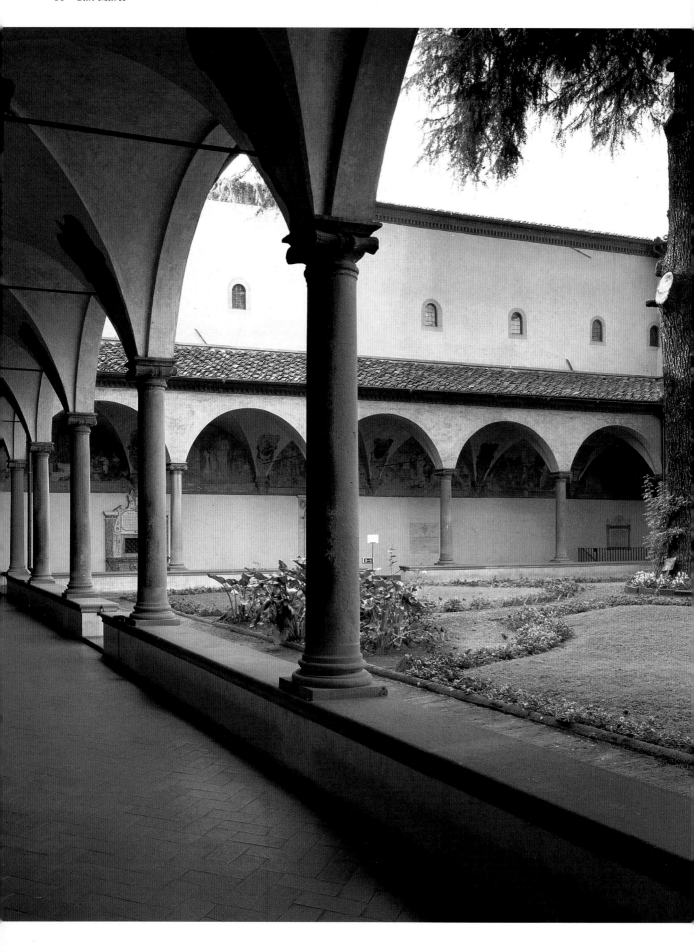

who was prior of the Monastery of San Marco at the time of its reconstruction between 1439 and 1444, and the patron of the establishment of the Dominican Order in the building. He was then chosen to be archbishop of Florence between 1446 and 1455, and was canonized in 1523.

The pictorial cycle was part of an official programme, following the dictates of the Counter-Reformation, which aimed to make the lives of Florentine saints more widely known, and which, starting at the end of the sixteenth century, was the motive for similar schemes of which there are numerous other important examples in Florence in almost all the large monastic complexes. The purpose was to offer an exemplary illustration of the life and miracles performed by a great champion of the religious life in Florence, and of the Dominican Order, by means of a figurative language that was easily understandable, so as to give greater force to the spiritual model intended for popular devotion. The decorative cycle was begun in the time of the prior Bernardo Alessandrini, and financed by many noble families who were attached to the Monastery or responsible for sponsoring chapels in the Church, and was largely finished by the third decade of the century. Many then famous Florentine painters took part, but the originator and perhaps the real and proper "promoter" of the cycle was Bernardino Poccetti (*c.*1548–1612), a good interpreter of the dictates of the Counter-Reformation and ubiquitous in Florence in numerous projects of this kind. He particularly appealed to the commissioners for the vivid scene-setting quality of his work and the narrative spontaneity he derived from his study of reforming Florentine painters such as Santi di Tito (1536–1603).

The decoration of the Cloister lunettes recommenced during the middle of the century and continued almost up to the beginning of the eighteenth century. The few frescoes painted during this second decorative phase allow us to follow the evolution of Florentine painting from a culture that was still largely based on the late sixteenth century up to the more modern techniques developed in Rome in the middle of the seventeenth century and on to the influence of the ethereal and gilded painting of Luca Giordano (1632–1705). To add clarity to the illustrated scenes explanatory inscriptions were painted beneath each lunette referring to the depicted episode. These were painted on either side of the armorial bearings of the commissioning family.

The decoration of the Cloister is completed by a series of eighteenth-century medallions depicting popes and Dominican cardinals side by side above the corbels on which each single cross-vault rests.

The cycle of paintings on the Life of St Antonino begins at the east wall and chronologically unfolds an anthology of episodes from the life of the saint.

Left: View of the St. Antonino cloister, looking towards the large Refectory

East Wall

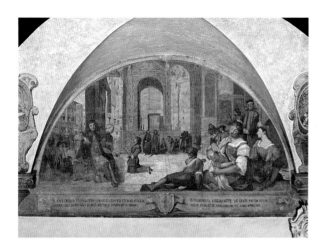

Bernardino Barbatelli known as Poccetti

Florence *c.*1548–1612

The Young Antonino adoring the Cross of Orsanmichele

Fresco, 234 x 440 cm

With this lunette, Poccetti commenced, in 1602, the narrative cycle of the life and miracles of St Antonino. He also painted the next lunette, which he signed. This fresco's luminous fulcrum is the figure of young Antonino kneeling piously before the Crucifix, but the theme is a pretext for a digression offering the spectator a slice of daily city life with prominent figures in the foreground, dominated in the background by the Church of Orsanmichele with its then open loggias.

Alessandro Tiarini

Bologna 1577–1668

Pope Eugenius IV at the Consecration of the Church of San Marco

Fresco, 237 x 439 cm

The last three lunettes on the east wall are by Tiarini, the only painter involved in the decoration of the first cloister of San Marco who was not a Florentine. He arrived in Florence in 1599 and remained there until 1606. Between 1602 and the year of his departure he worked on the cycle at San Marco. During his Florentine period he studied at the workshop of Domenico Cresti, known as Passignano, where he acquired a lively chromatic taste, and he seems to have rapidly immersed himself in the most modern Florentine culture, aligning himself with the prevailing devotional taste, with an unassuming and naturalistic style which he derived from Santi di Tito (1536–1603), via Poccetti. On this point some identifiable portraits of the foreground characters in the fresco *The Restoration of the Church of San Marco* are exemplary. There Lorenzo and Cosimo de' Medici, St Antonino and perhaps Michelozzo can be identified. Also in the final fresco on this wall the strength of some of the faces echoes the portrait skills of Santi di Tito and Jacopo dell'Empoli (1554–1640). The fifteenth-century interior of San Marco is reproduced in the painting and some Michelozzi-esque altars can be made out in the background.

South Wall

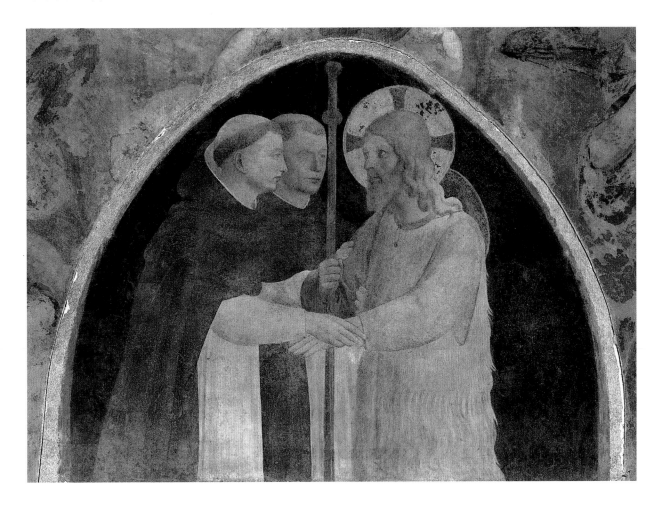

Fra Angelico

Vicchio del Mugello *c.*1395–Rome 1455

Christ received by Two Dominicans

Fresco, 120 x 127 cm

Christ received by Two Dominicans was painted above the
exit door to the Pilgrims' Hospice around 1440 to 1442
and at the same time as the other Angelico frescoes in
the Cloister.

The lunette depicts Christ, dressed as a pilgrim,
being welcomed by two Dominican monks. Of the five
lunettes painted by Angelico above as many doors
that give on to the Cloister, this is the only one with
a narrative content, metaphorically linked to the
functional use of the room to which the door granted
access, where the monks welcomed pilgrims. The
three-quarter length figures' full possession of the
space was achieved by the restrained semi-circle in
which the artist has placed them. The austere figure of
Christ, the intensity of the gesture with which his out-
stretched hand is emblematically grasped, the strength
emanating from the grip of the monk (in the centre)
clutches with both hands the arm of Christ, create
great emotional tension and convey a profound spirit
of charity and brotherhood.

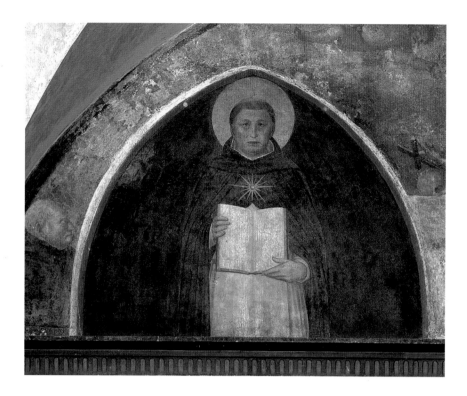

Fra Angelico

St Thomas Aquinas

Fresco, 108 x 145 cm

Above the door that today leads into the Pilgrims'
Hospice, between 1440 and 1442, Fra Angelico painted
St Thomas Aquinas holding up a sacred text, probably
the rule book of the Dominican Order. The solemn
full-frontal view of the three-quarter-length figure,
repeated in his three other lunettes in the Cloister,
does not detract from its confident spatial arrangement
and its three-dimensionality which adds vigour to the
force of the doctrinal and theological theme.

Giovan Battista Vanni

Florence 1600–Pistoia 1660

The Miracle of the Key found in the Belly of a Fish

Fresco

Vanni was commissioned in the mid-seventeenth
century to frame Fra Angelico's over-door paintings
and to fill the remaining space of the lunettes with
figures of Virtues and Angels. In the lunette above the
entrance to the Pilgrims' Hospice Vanni was able to
undertake a narrative subject, the only one assigned to
him in the entire cycle. The poor state of preservation
of the fresco does not allow full appreciation of its
chromatic qualities but some admirable examples
of still-life work depicting objects on St Antonino's
prie-dieu are remarkable.

West Wall

Sigismondo Coccapani

Florence 1583–1643

St Antonino unmasks Two Fraudulent Beggars

Fresco, 237 x 432 cm

This is among the best preserved lunettes of the St Antonino cycle and thus permits a close analysis of the culture of its painter, a man of many talents, a pupil of Bernardo Buontalenti (1536–1608) and Ludovico Cardi known as Cigoli (1559–1613). The fresco was painted immediately after Coccapani's return to Florence after his period in Rome where he had worked with Cardi on the frescoes in the Paolina Chapel in Santa Maria Maggiore. This experience had been of great importance for the cultural enrichment of the young painter who had been able to get abreast of the most up-to-date artistic techniques which in those years were only to be found in Rome.

The fresco is the earliest known work of the artist. Painted in 1613, it demonstrates Coccapani's development of Cigoli's later manner from which the "monumental" style in Roman frescoes derived, providing us with an imaginative and fanciful version of them.

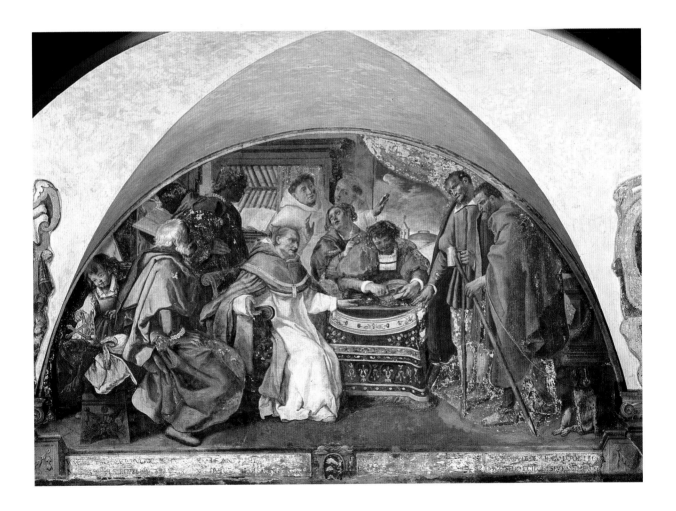

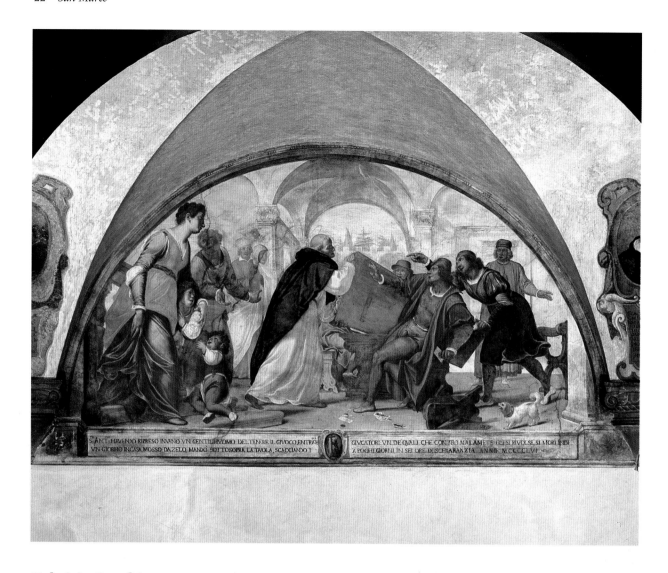

Fabrizio Boschi

Florence 1572–1642

St Antonino overturns a Gaming Table

Fresco, 237 x 435 cm

The lunette is one of two painted by Boschi on this wall around 1613 after the artist's return from Rome, where he had lived between 1602 and 1606 and where he had been given the opportunity to meet Rubens (1557–1640) at an early age. On his return to Florence he demonstrated that he had fully recaptured the Florentine illustrative tradition from the example of Poccetti, evident in this scene from its compositional neo-Mannerist structure of two counter-posed groups of figures framing the central group and from the architectural composition in the background.

North Wall

Fra Angelico

Vicchio del Mugello *c*.1395–Rome 1455

Christ on the Cross adored by St Dominic

Fresco, 340 x 206 cm

This great fresco was painted by Fra Angelico between 1440 and 1442 on the end wall of the west side and faces the visitor entering the Cloister. The sacred image illustrates a theme that is much repeated in a series of frescoes painted for the dormitory on the first floor and it serves as an introduction to the mystical atmosphere of the place. The fervent figure of St Dominic, depicted gazing in wonder at the Crucifixion, has enormous expressive power and the fresco illustrates

in an exemplary fashion the elements of Fra Angelico's art as he interprets the intense spirituality of the religious message in an idiom that is wholly of the Renaissance. The bleakness of the landscape, instead of detracting from the consistency of the figures, reinforces the spiritual strength rather than the physical vitality of the work. The precise location of the light source highlights the body of Christ, which is shaped with the same meticulous realism as the detailed face of the saint, and the latter is painted with the same sensitivity to surfaces as the copious flow of blood from the wounds of Christ.

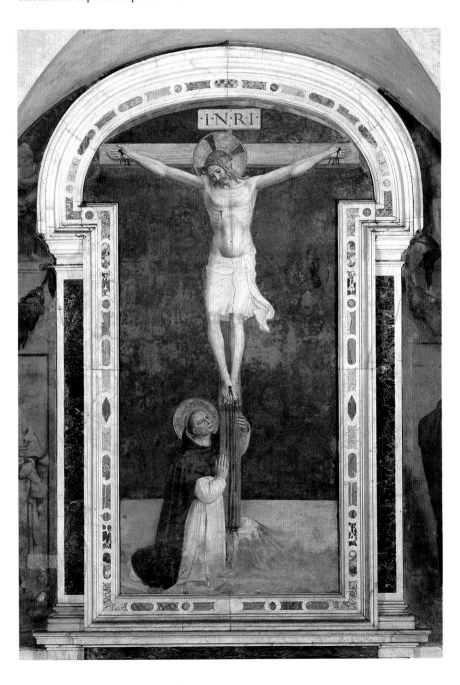

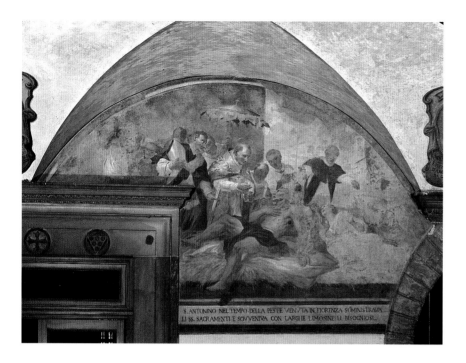

Pier Dandini

Florence 1646–1712

St Antonino gives Spiritual Succour to Victims of the Plague

Fresco, 234 x 440 cm

After an interval of nearly fifty years, the Cloister decoration continued with two lunettes on the Chapter House wall executed in 1692 by Pier Dandini, the brother of Cesare and pupil of Vincenzo Dandini. This fresco is a typical example of the Florentine style from Pietro Cortona and shows Dandini's regard for the hushed and muted tones of Florentine painters such as Simone Pignoni (1611–98).

Matteo Rosselli

Florence 1558–1650

The Death of St Antonino

Fresco, 235 x 442 cm

The final episode in the life of St Antonino was painted in 1626 by Rosselli, a talented fresco painter who still used the *buon fresco* technique that had been discontinued by most of his contemporaries. The best Florentine artists of the first half of the century were taught at his school. The taste for warmer and more intense hues and for sophisticated matching of colours, as can be seen from the figure of the young man kneeling on the extreme left, is evident from this lunette.

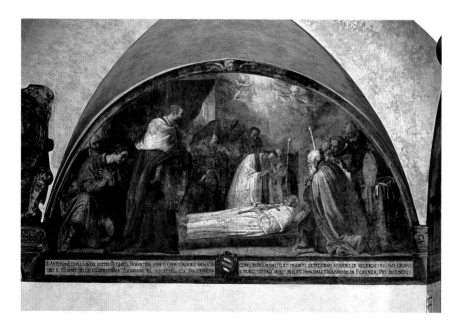

The Chapter House

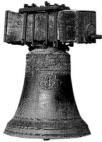

The bell stands in front of the Chapter House, which overlooks the Cloister. The great chamber is surrounded by wooden stalls where monks in assembly would meet, and dates structurally from the first monastic settlement; it was only marginally affected by the fifteenth-century rebuilding. However, there is documentary evidence of restoration work carried out in 1690 which also involved the large fresco of the *Crucifixion*. In the lunette above the door Fra Angelico painted *St Dominic holding the Rule in One Hand and Discipline in the Other*, eloquently alluding not only to the room where the monks held their meetings, but also to the administration of justice. Today the fresco has been taken down and is kept in the Museum's store. The synopia (preparatory drawing) is in the Lavatorium.

Bell

Bronze, 120 x 110 cm
Inv. San Marco n.348

The product of a mid-fifteenth-century Florentine workshop, maybe commissioned by Cosimo de' Medici. It subsequently becomes the symbol of the anti-Medici uprising after it was rung as the alarm-bell on the 6th April 1498, calling together the people of Florence to defend Girolamo Savonarola besieged in San Marco, and earned the epithet "la piagnona" (the whiner).

Baccio da Montelupo

Montelupo 1469–Lucca 1533

Crucifix

Carved and painted wood, height 170 cm
Inv. San Marco e Cenacoli, 1915, no. 278

The crucifix originally belonged to the Dominican Monastery, and it hung above the choir door in the Church, where Vasari records it. It was then moved to the "coro d' inverno de' Frati" and from there to the Chapter House. A payment invoice dated 1496 confirms that it was carved during Savonarola's priorship of San Marco and it was certainly inspired by the prior's severe spirituality.

The work is characterized by tense carving, over which the light casts a vibrant sheen, with the accent on realism beginning with the emphasis of colour. Details are picked out, such as the blood flowing copiously from the gaping wound, the strain of the tendons torn by the nails, the half-open mouth struggling for a final breath. The composition invites an immediate, emotional response – reflection on suffering and an inducement to contrition and mortification.

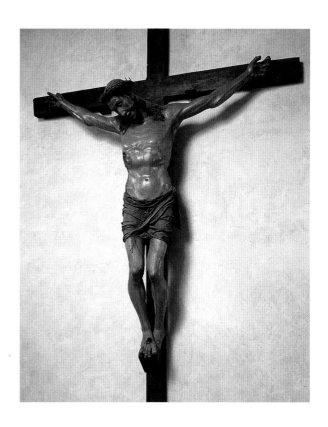

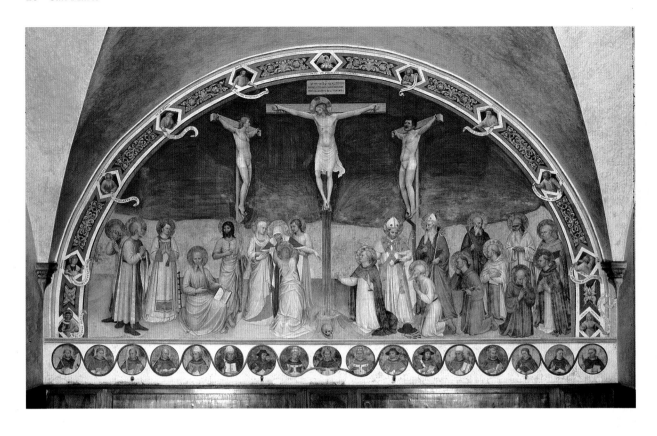

Fra Angelico

Vicchio del Mugello *c.*1395–Rome 1455

Crucifixion with Saints

Fresco, 550 x 950 cm

The fresco, which was completed in 1442, dominates the hall where the conventual chapter held their meetings concerning the religious community and also where judgements were meted out punishing disobedience to Dominican rule. The viewer is immediately struck by the grandeur of the composition, which should be understood as a reflection on the sacrifice of Christ on the Cross, the sorrowful transition to the path leading to the salvation of man from sin. Alongside the usual figures found in the Crucifixion iconography, such as the group of Marys with St John on the left, Fra Angelico has lined up in various manners and postures a series of saints, Fathers of the Church and the founders of the most ancient religious orders (not forgetting the saints associated with the Medici family: Saints Cosmas, Damian and Lawrence) who bear witness with their acts of contrition and meditation to the historic, philosophical and religious understanding of the inevitability of the drama. Each personality lives out the event in his own context, characterized by the most human and mournful gestures, such as the young St Damian on the left who covers his face in his hands.

The fresco is one of Fra Angelico's greatest masterpieces not only for the power contained in its message but on account of the formal ideas with which he establishes himself as a leading and superb interpreter of the new figurative language of the Renaissance. The group of figures, depicted in a landscape devoid of any naturalistic feature, is arranged paratactically rather than narratively. They stand out silhouetted against the background, which has become colourless owing to the loss of the original azurite pigment of which only the red and grey primer remain. The figures fully dominate the space and are picked out in depth by the foreshortening of the two obliquely disposed crosses. The figures, shaped by the light and shaded by an application of translucent paint, acquire three-dimensionality, and the effects of lustre on clothing, on the heads and in the light of the haloes demonstrate Fra Angelico's increasing interest in the study of light effects. The top scalloped-edge border contains hexagonal medallions depicting the figures of nine Patriarchs of the Church and the Eritrean Sibyl; the central one in the uppermost part of the border contains the Christological figure of the pelican. Below, starting with the central block depicting St Dominic, the founder of the order, are articulated on either side sixteen circular medallions with images of saints and illustrious members of the Dominican Order.

Ground Floor
The Pilgrims' Hospice

Beside the Cloister of St Antonino, on the right-hand side of the Museum's entrance, is the monumental Pilgrims' Hospice in which is housed the most outstanding collection of paintings on wooden panels by Guido di Pietro Comonly known as Fra Angelico. The room, the only one of its kind in the world, is almost entirely given over to the works of Fra Angelico.

Today the room spans three arches; once it was bounded by the original perimeter of the medieval Monastery complex. In the course of the fifteenth-century restoration Michelozzo rebuilt it on a higher level and installed cross-vaults to support the dormitory on the floor above. But at the time the room appears to have been divided, possibly in two parts, which would confirm the documentary evidence of a second entrance from the square. It would also have contained the final arch of the Refectory, added in 1526. It is possible that in fact the part that was actually used as the Hospice for lodging guests would have originally included the last arch on the Refectory side and the next one which is now part of it, as is indicated by the position of Fra Angelico's fresco of *Christ received by Two Dominicans* in the lunette above the door that now constitutes the room's exit. The other two arches in the direction of the Church, which in the current disposition of the Museum are joined to the third leading towards the Refectory, were probably used for other purposes, as is suggested by the figure of St Thomas, painted by Fra Angelico above the current entrance door to the room, since all the other subjects depicted in the lunettes are conceptually linked to the rooms to which they grant access.

The Fra Angelico Gallery

The collection of panel paintings in the Pilgrims' Hospice forms the greatest existing record of the work of Fra Angelico in the world. Originally in Florentine churches and monasteries or from the surrounding area, they passed into the ownership of the Florentine galleries after the suppression of the monasteries in 1866 and the ensuing transfer of their property to the state. The idea of collecting together under one roof the numerous works of the painter was the result of a project to transform the Dominican monastery into a museum with the intention of forming a collection of documents concerning the religious and artistic history of the Dominican Order.

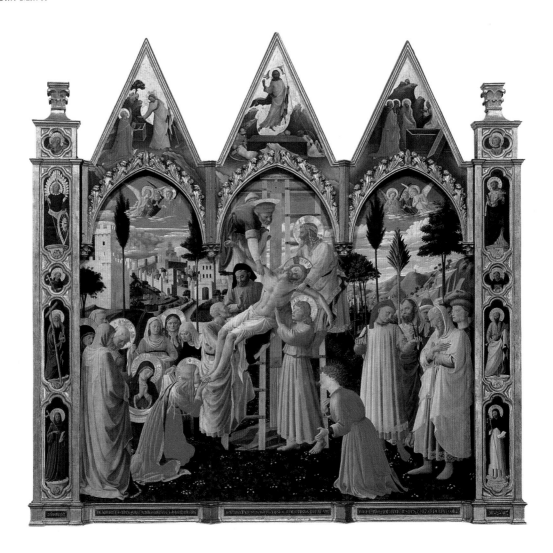

Fra Angelico

Vicchio del Mugelo *c.*1395–Rome 1455

and Lorenzo Monaco

Siena? *c.*1370–Florence 1425

Deposition

In the pinnacles: *"Noli me tangere", The Resurrection, The Three Marys at the Sepulchre.*

In the pilasters: *Saints John, John the Baptist, Anthony Abbot, Lawrence, Benedict, a Prophet, Michael, Francesco, Andrew, Giovanni Gualberto, Peter, Peter Martyr, Paul, Dominic, a Prophet, Stephen, a Bearded Saint, Augustine and Jerome.*

Panel, 185 x 176 cm
Inv. 1890 no. 8509

The panel was originally in the sacristy of the Florentine Church of Santa Trinità and had been commissioned from Lorenzo Monaco in 1422 or 1423. It had probably been destined for an altar that once existed in the small sacristy of the church, built for Palla Strozzi and completed in 1423. Lorenzo Monaco painted the pinnacles with the *Three Stories of Christ post*

mortem, and the predella, now in the Galleria dell'Accademia in Florence, which depicts episodes from the lives of St Onophrius and St Nicholas. The painter's death in 1425 brought work on the painting to a halt until ten years later when it was given to Fra Angelico to finish and was probably completed by 1434, the same year in which its patron was forced to leave Florence.

The grandiose and eloquent composition offers an original version of a common theme, choosing the moment in which Christ's body is being lowered from the Cross; from the central axis the figures are arranged along the four diagonals. They are solemn and composed with measured and eloquent gestures commensurate with the Holy Image in which a single space is fashioned out of a tripartite space, as in medieval altarpieces. The perspective leads to a distant landscape, bathed in indirect light, and provides relief from the monumental groups of figures and leads the eye away from the drama in the foreground to the consoling vision of a polyhedrical image that is probably meant to represent Florence.

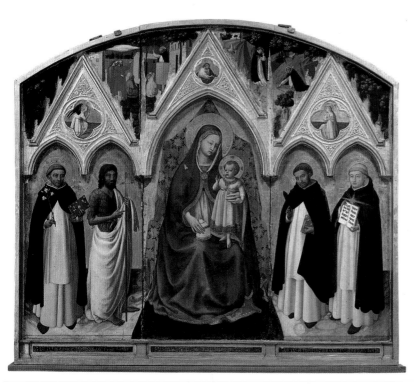

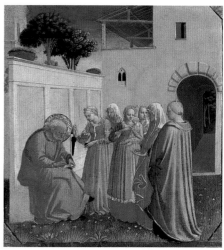

Fra Angelico

Madonna and Child with Saints Dominic, John the Baptist, Peter Martyr and Thomas Aquinas

In the pinnacles: *The Annunciation; The Eternal Father.*

Between the pinnacles: *Preaching and The Martyrdom of St Peter (Triptych of St Peter Martyr)*

Panel, 137 x 168 cm
Inv. 1890 no. 8769

The panel was painted for the Dominican nuns at the Florentine Convent of St Peter Martyr. Vasari describes it as hanging in the Church of San Felice in Piazza where the nuns had moved in 1553. It was probably finished by 1429, when a document records an outstanding payment for the painting at the Convent of San Domenico in Fiesole. It is the first work that can be attributed to Fra Angelico with certainty. The tripartite structure of the panel – still a Gothic conception – did not prevent the artist from intimating the figures' distinct setting in the painting, achieved by following the sharp cadence of the drapery so that the figures tend to form a semi-circle around the Madonna. This demonstrates – in the slight leftwards rotation that amplifies the possession of space – a clear debt to Masaccio (1401–28), while the richness of the fabric covering the throne would indicate the influence of Gentile da Fabriano (*c.*1370–1427). Gentile da Fabriano may also have painted the narrative episodes in the interstices of the pinnacles. Their detail and acute naturalistic observation reveal the painter's knowledge of miniature painting, an art he had practised in his youth.

Fra Angelico

The Naming of John the Baptist

Panel, 26 x 24 cm
Inv. 1890 no. 1499

This panel comes from a dismantled predella, the same source, according to scholars, as the panel of *St James freeing Hermogenes* in the Fort Worth Museum in Texas along with others that have been identified recently. They came from an altarpiece that perhaps disappeared in the last quarter of the eighteenth century, if the recent hypothesis that the panels were part of the Hugford Collection in 1786 is to be believed. Structural similarities, such as the gold gleanings on the panels, would seem to link the panels to the *Annunciation* predella in the Prado, which was originally in the Convent of San Domenico in Fiesole. The panel can be dated with certainty as being pre-1435, since in that year Andrea di Giusto (active 1423–50) made a copy of the painting for the polyptych predella now in the Prato Pinacoteca. Dating it around the beginning of the third decade of the century is fairly convincing because of its similarity to frescoes by Masaccio (1401–28) in the Carmine, in the studied balance between figures and architecture and the use of light to play an essential part in shaping figures.

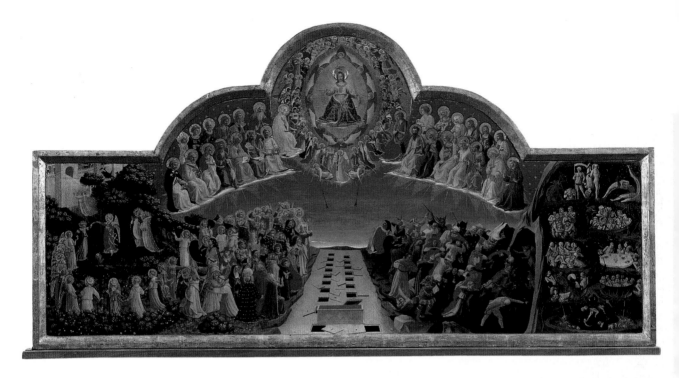

Fra Angelico

The Last Judgement

Panel, 105 x 210 cm
Inv. 1890 no. 8505

The panel was probably painted in 1431 for the
Church of Santa Maria degli Angeli at the same time
as Ambrogio Traversari, who had given a significant
impetus to the church decoration, was elected abbot
general of the Camaldolensian Order.

Fra Angelico was faced with compositional
problems, given the unusual shape of the panel which
seems to have once occupied a position over the seat
used by the priest during the celebration of high mass.
These he boldly resolved with the complex conception
of separating the sphere of the Damned from the
sphere of the Elect by a central line of uncovered
tombs that recede to the horizon, giving the work an
extraordinary depth of vision. On high he painted the
celestial choirs in a hemicycle on either side of Christ
and the surrounding angels. Hell is depicted so literally
that it is hard not to think of Dante, and the group of
the Elect singing carols on their way to Jerusalem; this
panel reaches the heights of absolute figurative
lyricism.

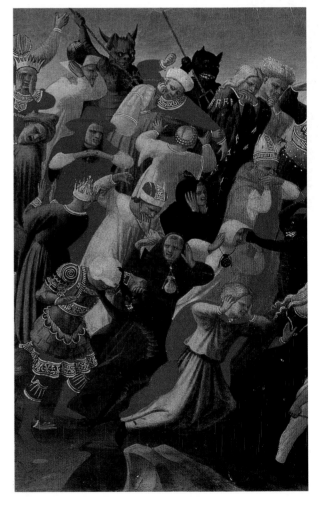

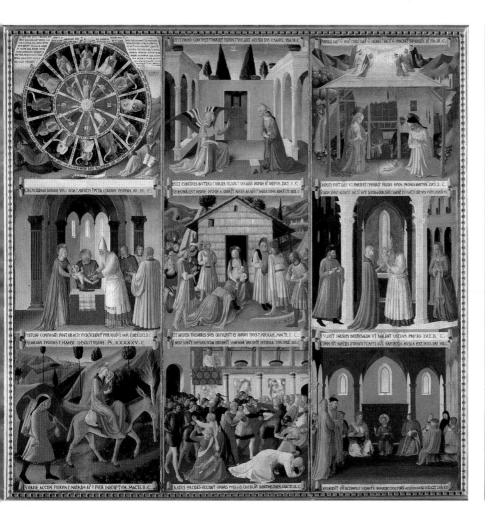

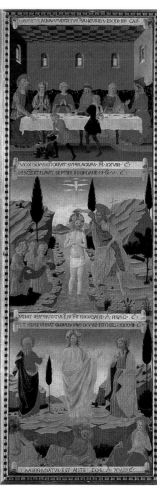

Doors of the Silver Cabinet

Fra Angelico

The Mystic Wheel, Annunciation, Nativity, Circumcision, Adoration of the Magi, Presentation of Jesus in the Temple, Flight into Egypt, Massacre of the Innocents, Christ teaching in the Temple

Panel, 123 x 123 cm
Inv. 1890 nos 8489, 8490, 8491

Alesso Baldovinetti

Florence 1425–99

The Marriage at Cana, Baptism of Christ, Transfiguration

Panel, 123 x 44 cm
Inv. 1890 no. 8510

Fra Angelico

*The Raising of Lazarus, Entry into Jerusalem, Last
Supper, Betrayal of Judas, Washing of the Disciples'
Feet, Communion of the Apostles, Agony in the Garden,
Kiss of Judas, Arrest of Christ, Christ before Caiphas,
Mocking of Christ, Flagellation*

Panel, 123 x 160 cm
Inv. 1890 nos 8492, 8500

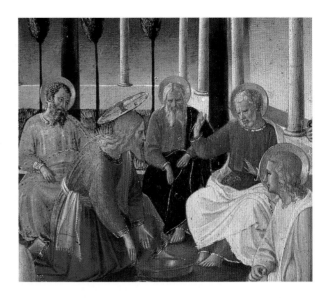

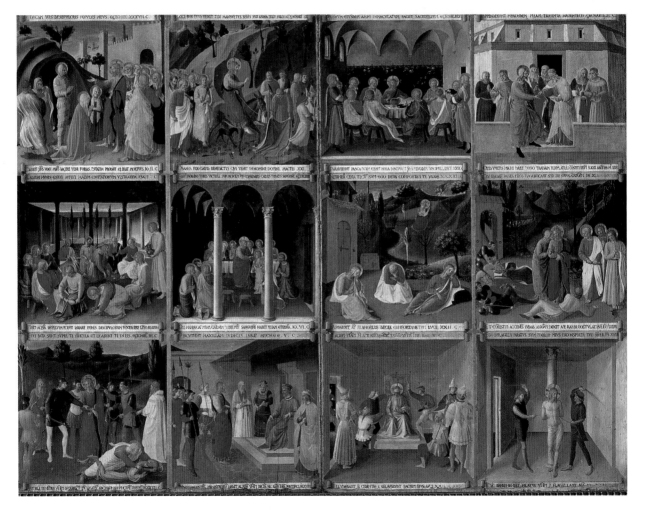

Fra Angelico

The Ascent to Calvary, Christ stripped of his Garments, Crucifixion, Lamentation over the Dead Christ, Christ in Limbo, Three Marys at the Sepulchre, Ascension, Pentecost, Last Judgement, Coronation of the Virgin, "Lex Amoris"

Panel, 123 x 160 cm
Inv. 1890 nos 8501, 8502

These 35 episodes from the Gospels, bordered by two scrolls with verses from the Old and New Testaments, which are now assembled in four groups, were originally part of the doors of the cupboard, or more exactly the niche where the silver or more valuable reliquaries – now in the Church of Santissima Annunziata – were kept. The cabinet was modified in 1461 when Piero del Massaio (third quarter of the 15th century) was commissioned to paint further panels, possibly twelve, and Fra Angelico's panels were used to complete a new locking mechanism. Painted between 1451 and 1453, it represents the zenith of Fra Angelico's Florentine period, as is clear from the originality of its complex, iconographic conception, even if part of its execution should be attributed to his workshop and to Alesso Baldovinetti (*c*.1426–99). The cabinet was broken up after the removal of the locking mechanism, and three of the nine episodes originally credited to Baldovinetti are stored in the Museum. Scholars tend to agree that Fra Angelico painted the first nine episodes – compositions of far-reaching scope, set in architectural contexts familiar to Roman monumental architecture – in which the perspective rigour is accompanied by a depth of effect and a rendition of the phenomenon of light that characterizes the later works of the painter.

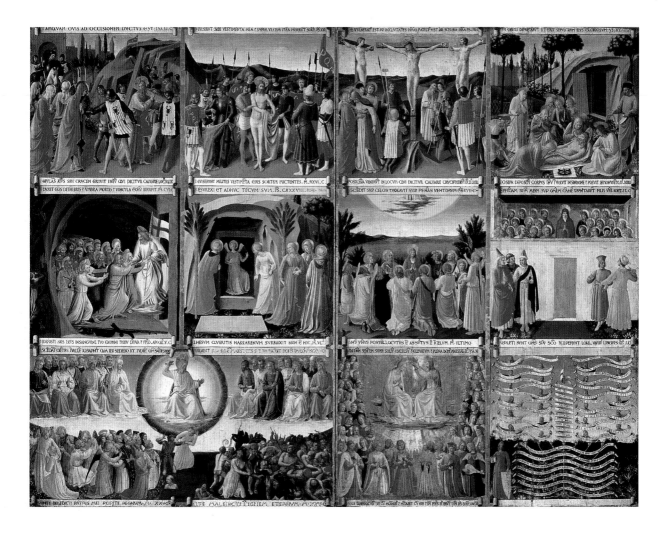

Fra Angelico

Tabernacle-Reliquaries of Santa Madonna with Child, God the Father, Angels

In the predella: *Saints Peter Martyr, Dominic and Thomas Aquinas*
(The Madonna of the Star)

Panel, 84 x 51 cm
Inv. San Marco no. 274

The Annunciation and Adoration of the Magi

In the predella: *Madonna and Child with Saints Catherine of Siena, Apollonia, Margaret, Lucy, Mary Magdalen, Catherine of Alexandria, Agnes, Cecilia, Dorothea and Ursula*

Panel, 84 x 50 cm
Inv. San Marco no. 276

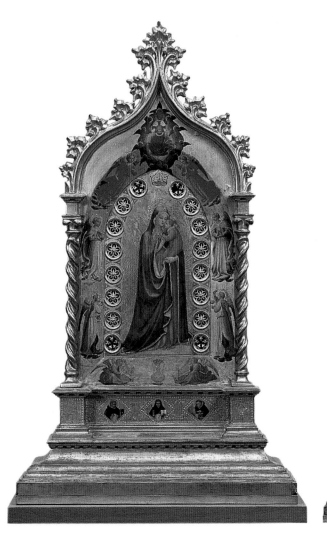
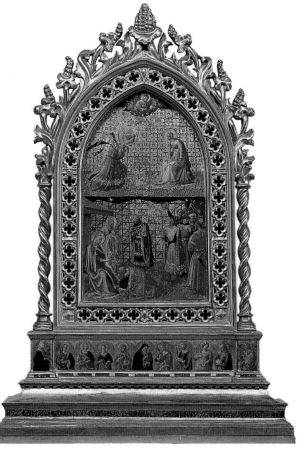

The Coronation of the Virgin

In the predella: *Adoration of the Child and Angels*

Panel, 69 x 37 cm
Inv. San Marco no. 275

These three small precious tablets formed part of a
group of four reliquaries, or more probably doors to
small niches containing reliquaries, and are likely to
have been painted at the beginning of the 1430s. They
were commissioned from Fra Angelico by Fra Giovanni
Masi, sacristan of Santa Maria Novella, the mother
church of the Dominicans, who died in 1434. The
fourth reliquary panel, generally agreed to be the one
preserved in the Isabella Stewart Gardner Museum in
Boston, depicts *The Burial and Assumption of the Virgin*.

These three most famous paintings represent the
culmination of Fra Angelico's compositional and
conceptual achievements on the threshold of what
would be a crucial new decade for the painter. Beside
the brilliant gold, and the delicacy and refinement of
the indentations which stem from the late-Gothic style
of Gentile da Fabriano (*c*.1370–1427), and particularly
in the so-called *Madonna of the Star*, there are exact
attempts to achieve a sense of space and substantiality,
most explicitly in the *Coronation of the Virgin*, a
precursor of his more realized conception of the same
subject on a large scale which today hangs in the
Louvre. The reliquary panel of the *Annunciation and the
Adoration of the Magi* is characterized by subtle descrip-
tive refinements from the art of miniature painting
that Fra Angelico was still practising in those years,
and the soft delicate forms that Masolino had adopted.

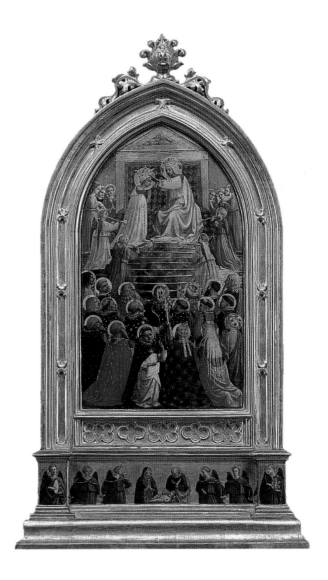

Fra Angelico and the Workshop of Lorenzo Ghiberti

Florence *c.*1370–1455

Linaioli Tabernacle

Madonna and Child Enthroned

On the exterior of the door panels: *St Mark and St Peter;* on the interior: *St John the Baptist and S. Mark.*

In the predella: *St Peter preaching before St Mark, Martyrdom of S. Mark, Adoration of the Magi.*

Marble and panel, 292 x 176 cm (closed)
Each panel of the predella: 39 x 56 cm
Inv. 1890 no. 879

The precise installation date of Fra Angelico's monumental tabernacle commissioned for the powerful Guild of Rigattieri, Linaioli e Sarti (Cloth, Linen and Tailors' Guild) is known: 11 July 1433. At the same time the execution of the marble frame was entrusted to two members of Ghiberti's workshop, Jacobo di Bartolomeo da Settignano and Simone di Nanni da Fiesole (active in the first half of the fifteenth century), following Ghiberti's own designs. Ghiberti's collaboration with Fra Angelico was the inspiration behind the cadenced rhythms of the sickle-shaped drapery – often evident in Fra Angelico's works – here realized within a distinct Renaissance context. The elegant, larger-than-life togaed saints on the doors of the tabernacle seem to adhere so closely to Ghiberti's ideas as to suggest that they originated in a drawing by the sculptor. The Madonna's composition in the centre of the tabernacle derives from Lorenzo Monaco (1370–1425), while its coherent spatial definition has echoes of Masaccio (1401–28). In the predella overtones of Gentile da Fabriano (*c.*1370–1427) can be discerned in the naturalistic interpretation of the weather, as in the episode of the *Martyrdom of St Mark.*

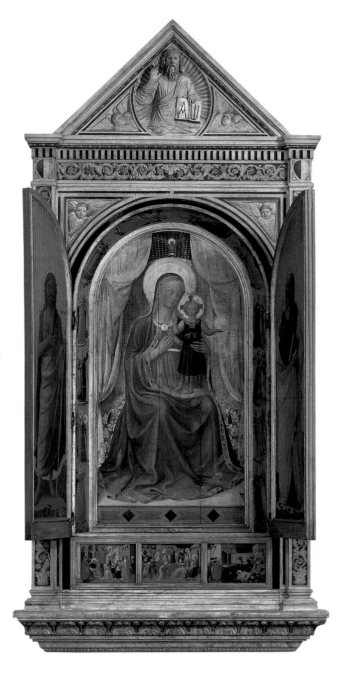

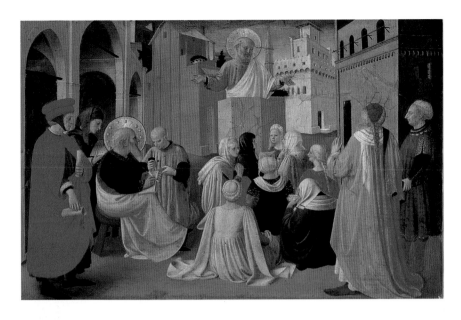

Left-hand predella panel

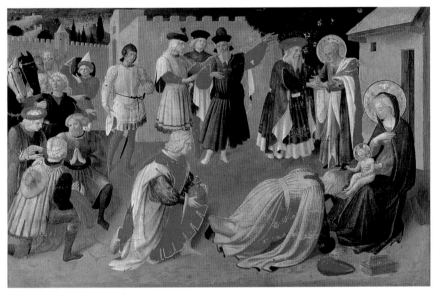

Centre predella panel

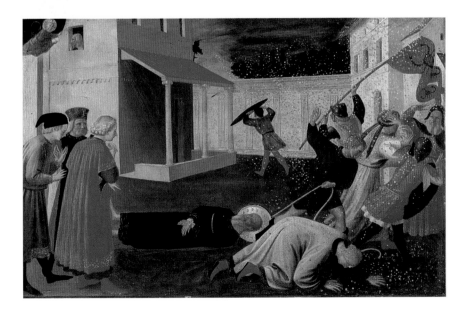

Right-hand predella panel

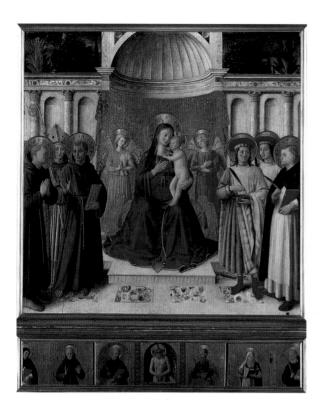

Fra Angelico

Madonna and Child enthroned with Saints Anthony of Padua, Louis of Toulouse, Francis, Cosmas, Damian and Peter Martyr

In the predella: *Ecce Homo with Saints Dominic, Bernadine, Peter, Paul, Jerome and Benedict (Bosco ai Frati Altarpiece)*

Panel, 174 x 174 cm
Predella, 26 x 174 cm
Inv. 1890 nos 8503–8507

This is the last known panel painting by Fra Angelico and it was carried out between 1450 and 1452 during the artist's last period in Florence. It can be accurately dated because of the presence of St Bernadine, who was canonized in 1450, among the saints in the predella. The painting was commissioned for the Franciscan Monastery of San Bonaventura al Bosco ai Frati in the Mugello which had been rebuilt by Michelozzo on the instructions of Cosimo de' Medici in 1438. The presence of Saints Cosmas and Damian suggests that the panel too was a Medici commission. The classical architecture forming the background, sanctified by the central niche surmounted by a ribbed, bowl-shaped vault, confers a sense of power over the area where, in two concentric hemicycles, the figures of the saints are disposed. The close affinity with Fra Angelico's works from his Roman period is substantiated by the solemnity of the delicately drawn figures, the metallic brilliance of the haloes and the brocades draping the Virgin's cushion and throne.

Fra Angelico

Madonna and Child enthroned with Angels and Saints Cosmas, Damian, Lawrence, John the Evangelist, Mark, Dominic, Francis and Peter Martyr

In the predella: *Burial of Cosmas and Damian with their Brothers; Healing of the Deacon Justinian (San Marco Altarpiece)*

Panel, 220 x 227 cm; each panel of the predella: 37 x 45 cm
Inv. 1890 nos 8506, 8494, 8495

Fra Angelico painted this altarpiece between 1440 and 1442 for the Church of San Marco to replace the triptych by Lorenzo di Niccolò. The latter had been presented to the Dominican monastery of Cortona by Cosimo de' Medici in 1438 when, on Cosimo's instructions, Michelozzo began restructuring the Church, doubling the size of the tribune and building a new altar. The altarpiece was certainly in place by Epiphany in 1443 when Pope Eugenius IV consecrated the new Church of San Marco.

The panel is in a poor state of preservation, worn on the surface, owing to defective restoration work in the past. However the magnificence of the design is still apparent in its lack of compositional divisions, its sumptuous embellishments and its atmospheric translucence. The illusionistic invention of the simulated curtains drawn on either side was innovative, as was the *trompe l'oeil* simulated tabernacle with the Crucifixion in the foreground. The composition is set in the open air, rather than in an interior, against a distant, evocative background that extends beyond the line of trees. It became a paradigm that was infinitely developed by painters during the second half of the fifteenth century. Nine panels with episodes from the lives of the Medici saints, Cosmas and Damian, formed the predella, only two of which remain; the others are located in museums in Dublin, Munich, Paris and Washington. In the *Burial of Cosmas and Damian* Fra Angelico accomplishes the representation of an urban scene that is easily recognizable as the square and facade of the Church of San Marco. Equally realistically portrayed are the gestures of amazement on the part of the bystanders who hear the miraculous dromedary speak.

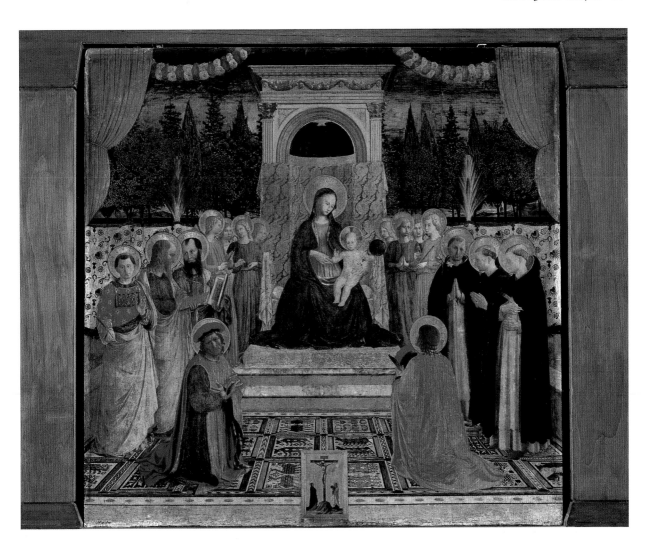

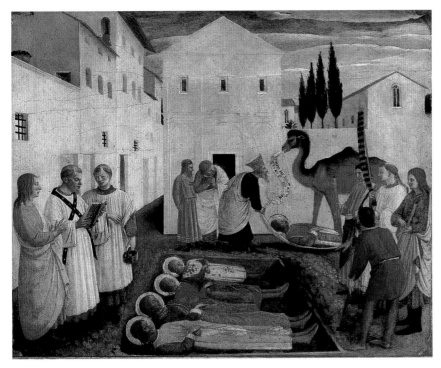

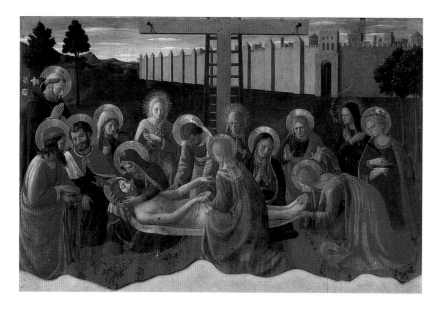

Fra Angelico

Lamentation over the Dead Christ

Panel, 105 x 164 cm
Inv. 1890 no. 8487

The painting was begun in 1436 some time after 13 April when an instalment payment was made by the Benedictine monk Sebastiano Benintendi, prior of the Dominican Orders in Fiesole and in Florence, who had commissioned it. It was probably finished in 1441, a date which appears on the hem of the Virgin's cloak. It was painted for the Confraternity of the Cross at the Temple where prisoners who had been condemned to death spent the last hours of their lives. The subject of the painting itself, of course, is a meditation on death, expounded in a complicated construction which is analogous to numerous medieval compositions, though here it is complicated by the number of characters and the difficulty of identifying them. Among others the Blessed Villana delle Botte can be seen wearing widow's weeds. She was an ancestress of the commissioner who may be depicted on the extreme left in the guise of St Dominic. The spatial disposition of the figures along more than one line was expertly achieved by Fra Angelico; the power of the dramatic action that has just happened is eased by the vision of a universal city whose walls, bathed in light, are broken by a diminishing sequence of towers.

Zanobi Strozzi

Florence 1412–68

Madonna and Child enthroned with Four Angels

Panel, 127 x 110 cm
Inv. 1890 no. 3204

This is the only painting in the Pilgrims' Hospice that does not belong to Fra Angelico's oeuvre. It was originally in Santa Maria Nuova and almost all critics agree in attributing it to Zanobi, an artist whose work has been better defined in recent years. The panel is a close reworking of Fra Angelico's themes, and in particular its derivation from the *Linaioli Tabernacle*, in place by 1433 – a year which constitutes a useful reference point after which the panel must have been painted – is evident.

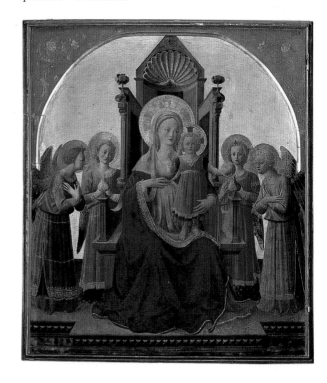

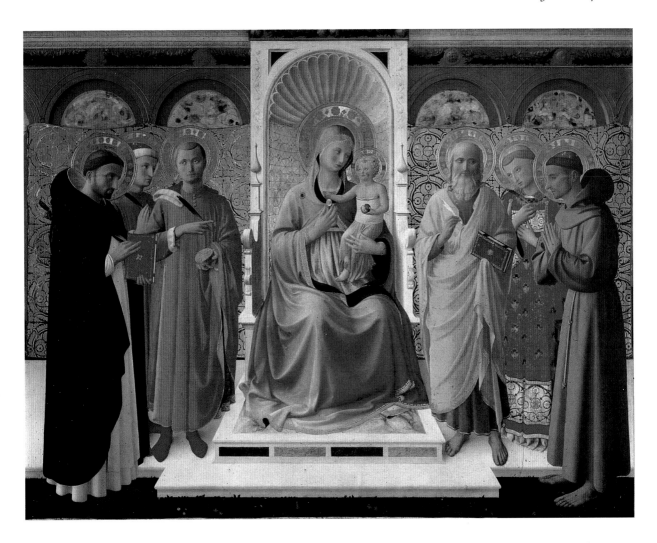

Fra Angelico

Madonna and Child enthroned with Saints Peter Martyr, Cosmas, Damian, John the Evangelist, Lawrence and Francis

In the predella: *Healing of Palladia, Cosmas and Damian before Lycias, Cosmas and Damian saved from Drowning, Attempt to kill Cosmas and Damian by Burning, Attempt to kill Cosmas and Damian by Crucifying and Stoning, Beheading of Cosmas and Damian*
(Annalena Altarpiece)

Panel, 180 x 202 cm
Inv. 1890 nos 8493, 8486

This is one of the first paintings commissioned by the Medici after Cosimo de' Medici's return from exile. It was perhaps intended for one of the altars in the Church of San Marco but it passed into the ownership of the Monastery of St Vincenzo di Annalena, founded by Annalena Malatesta in 1453. It is thought to date from 1434, earlier than the *San Marco Altarpiece*.

Like the *San Marco Altarpiece*, the predella contains *Episodes from the Lives of Saints Cosmas and Damian*, but certain old-fashioned details, such as the harsh, fanciful landscape, indicate that it was painted before the adjacent *San Marco Altarpiece*. The architectural features appear to be still fully assimilated in the Florentine tradition and correspond to those common in the fourth decade of the fifteenth century. The panel is the first humanist *Sacra Conversazione* where space is conceived as a constituent of perspective and as a continuation of actual space. It is also probably the first of the rectangular panels which, by 1434, had been adopted for the altars in the Church of San Lorenzo, perhaps on Brunelleschi's recommendation.

The East Wing

All the ground-floor rooms that stretch out eastwards, along what is now Via La Pira, were the domestic offices of the religious community, such as kitchens, laundry and ironing rooms, granary, barber's, bakery and stores. These rooms, more than any others, have been subject to alteration from their original functions during the transformation of the monastic complex into a museum.

Recent examinations of the Monastery's structure have revealed that these rooms, given their specific characteristics and configuration, are the oldest in San Marco and that during Michelozzo's rebuilding, intended to provide a more decorous mien to the Church and Monastery, they underwent only marginal alteration. This enterprise was undertaken by Cosimo and Lorenzo de' Medici in order to regain the goodwill of the Florentines and specifically involved alterations to communal areas such as the Cloister, the Refectory, the Chapter House, the Guest Chambers, Dormitories and the Library, or, of more immediate impact on the public, the Church itself.

The Lavatorium

At the north-east corner of the Cloister of St Antonino, a door surmounted by a Fra Angelico lunette of the *Pietà* leads into the Lavatorium, an antechamber of the Large Refectory. The fresco occupying the lunette conveys a strong emotional impact through the lean descriptive tension of the pale body of Christ and the minimal perspective of the tomb. It was intended to suggest that the resurrection of the body was a metaphor for eternal life which was attained by nourishment from the body of Christ, just as the monks passed through the door to obtain earthly sustenance.

The room was originally furnished with a lavatorium of which no trace remains today. The function of the lavatorium, according to monastic custom, was to permit the monks to cleanse themselves before their meals in accordance with the biblical verse: *"Lavabo inter innocentes manus meas, et circumdabo altare tuum, Domine"* ("I will wash my hands among the innocents, and will surround your altar, Lord").

Fra Bartolomeo

Florence 1473–1517

Last Judgement

Detached fresco, 360 x 375 cm
Inv. 1890 no. 3211

On 8 January 1499 Gerozzo Dini commissioned Baccio della Porta, not yet known as Fra Bartolomeo, to paint a fresco above the tomb of his mother, Monna Venna, in the Chiostro delle Ossa dell'Ospedale di Santa Maria Nuova where Gerozzo Dini was an usher. The contract was particularly precise regarding the characteristics of the painting and entailed portraits of Dini and his mother. The fresco was to be completed by July of the same year but it was still unfinished half way through 1500 when Fra Bartolomeo, profoundly affected by the experience of Savonarola, decided to become a monk. By this time only the upper half of the fresco had been completed and Mariotto Albertinelli (1474–1515), a friend and later an associate of the monk, was commissioned to finish it. Nonetheless, because of the rapid deterioration of the fresco in the course of a century, thanks to the unwholesomeness of its location, it

required early restoration work, which was carried out by Matteo Rosselli in 1628. When the Cloister was demolished in 1657 the fresco was divided into nine sections and relocated in another cloister of the Ospedale but during this process the portraits of the patrons by Albertinelli were lost. Following further progressive and relentless deterioration, the fresco was taken from the wall in 1871. Recent restoration has dealt with the uppermost paint layer, which was separated from its backing and then repositioned on an inert base.

Notwithstanding the vicissitudes that it has suffered ever since it was first put into place, this work – the last by the monk before he took holy orders – has a conceptual magnificence which is still apparent. The impressiveness of the work as a whole is based on the harmony of fifteenth-century Classicism which would achieve its zenith in the classical period of the Italian Renaissance during the first years of the following century. The spatial equilibrium of the composition was used as a model by Raphael (1483–1520) when he painted the *Disputa sul Sacramento* for the Vatican in 1509.

The Large Refectory

The magnificent chamber reached from the Lavatorium is still, in part, the fourteenth-century medieval structure dating from the time of the Silvestrine monks. It is an immense room with four spans of ribbed cross-vaults. The keystone in the centre of each vault is a stone roundel bearing the image of St Benedict, in memory of the founder of the Benedictine Order from which the Silvestrines originated. At the time of the Michelozzo rebuilding this room was among the best preserved of the original monastic complex, but it comprised only the first two spans of the present four. In 1437 Michelozzo added a third, above which he began the construction of the first twenty cells along the first (east) corridor on the floor above. On the lower part of the wall Fra Angelico painted a Crucifixion which has unfortunately disappeared in the course of the successive alterations. Giovanni Antonio Sogliani was commissioned in 1536 to paint the great fresco of the *Miraculous Supper of St Dominic*, which dominates the room, on the end wall.

In the current arrangement of the Museum, the Refectory houses a collection of religious and devotional paintings, mostly from the sixteenth century and linked to the so-called school of San Marco created by Fra Bartolomeo.

Giovanni Antonio Sogliani

Florence 1492–1544

Miraculous Supper of St Dominic

Fresco, 500 x 792 cm

The great fresco fills the end wall of the Refectory, occupying (except for the wooden stalls) all the available space both in breadth and height. Bordered by a *trompe l'oeil* frame, it is signed A.S. (Anno Salutis) and the date 1536 can be seen on the side pilasters. In a stage-like setting the perspective leads the eye beyond the frame and opens up on to two figurative backdrops, bordered by classical architecture that frames an expansive landscape in the background. The upper part of the fresco depicts a *Crucifixion*, a typical theme of fourteenth-century refectory decoration, accompanied by the weeping figures of St Mary and St John and by the Dominican saints Antonino and Catherine of Siena. The lower part depicts the *Last Supper*, which by the fifteenth century tended to prevail over the Crucifixion as a motif, but here it has been transformed, albeit still connected to the Eucharist, with a theme more closely tied to the Dominican Order, that is the *Miraculous Supper of St Dominic*, a composition with evident topical relevance. The figure on the extreme left, with his head turned towards the spectator, is a portrait of the young novice Molletti, who financed the painting of the fresco, as Vasari notes. Vasari also records that Sogliani had

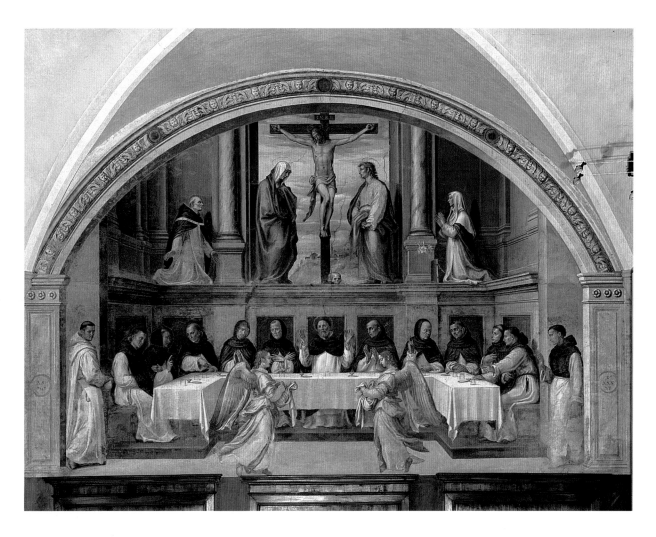

initially wished to paint a different subject, the Miracle of the Loaves and Fishes, but this had been rejected by the monks who desired "ordinary, positive and simple things". Various drawings and a final sketch of this subject have been recently identified in the Gabinetto Disegni e Stampe degli Uffizi.

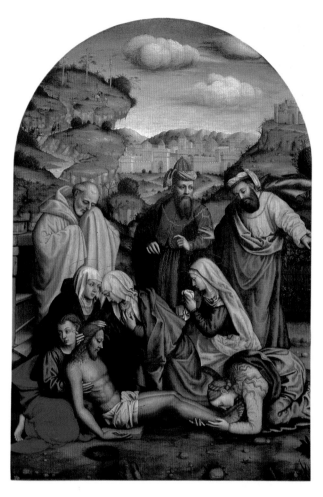

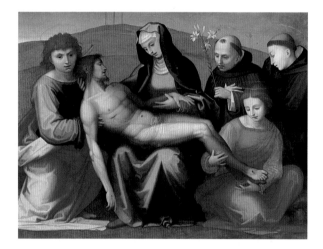

Fra Paolino

Paolo di Bernardino del Signoraccio, Pistoia
*c.*1490–Florence 1547

Lamentation over the Dead Christ

Panel, 134 x 172 cm
Inv. 1890, no. 3473

This canvas, painted in 1519, is a youthful work by
Fra Paolino, a follower and devoted pupil of Fra
Bartolomeo. When Fra Bartolomeo died, Fra Paolino
assumed control of the monastery workshop that his
master had founded, and he inherited all the artist's
drawings and sketches. The *Lamentation* was painted
for the high altar of the church of the Dominican
Convent of the Maddalena alle Caldine, where it was
later replaced by a copy. According to a history of the
convent, Fra Bartolomeo had sketched the composition
before his death. Thus this painting shows the greatest
similarity between the styles of the two painters.

Plautilla Nelli

Florence 1523–88

Lamentation over the Dead Christ

Panel, 288 x 192 cm
Inv. 1890, no. 3490

This panel is by Sister Plautilla Nelli, mother superior
of the Convent of St Catherine of Siena in Piazza San
Marco, and it was commissioned for the Convent itself.
She had been a pupil of Fra Paolino, who had
bequeathed her his own drawings together with those
of Fra Bartolomeo, his teacher. She is one of the few
female artists whose work has survived to the present.
Vasari mentioned her with admiration but this large,
convoluted composition is extremely derivative of Fra
Bartolomeo's and Fra Paolino's iconography, though
more directed towards strictly devotional religiosity.
The figures are painted somewhat rigidly and the
austere, rocky landscape appears to have been
influenced by northern European engravings.

Ridolfo del Ghirlandaio

Florence 1483–1561

The Virgin gives the Girdle to St Thomas with Saints Francis, John the Baptist, Ursula and Elisabeth of Hungary

Panel, 370 x 240 cm
Inv. 1890, no. 3472

The panel is attributed to Ridolfo del Ghirlandaio, Domenico's son. Its closeness to Fra Bartolomeo's serious tone is coupled with a regard to the work of Raphael (1483–1520), with whom, according to Vasari, Ridolfo was on very friendly terms.

Giovanni Antonio Sogliani

The Virgin gives the Girdle to St Thomas with Saints John the Baptist, Louis (?), Giovanni Gualberto and James

Panel, 235 x 216.5 cm
Inv. 1890, no. 8642

This large panel originally hung in the Church of Santa Maria e Giuseppe in Prato and the date, A.D. MCCCCCXXI (The Year of our Lord 1521), can be seen painted on the front of the tomb. In this work Sogliani displays various elements of his technique. The style derived from his teacher, Lorenzo di Credi (1459?–1537), who also influenced the compositional structure, but the solemnity of the figures originates from Fra Bartolomeo, and the chiaroscuro suggestions may have been inspired by Andrea del Sarto (*c.*1487–1530).

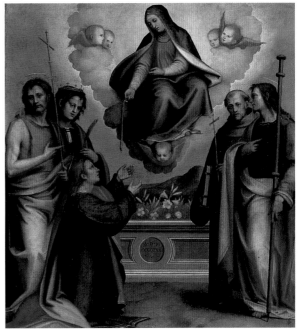

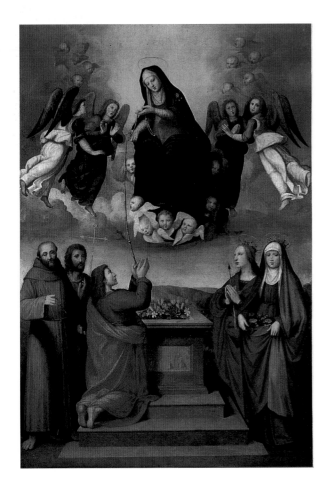

The Fra Bartolomeo Room

The present Fra Bartolomeo Room had originally been a kitchen equipped with a large fireplace and a well and it led off from the small cloister, the Chiostrino della Spesa. A spiral staircase in the Cloister connected it to the dormitories above and the basement rooms below.

 The room is dedicated to the second painter of great importance who lived in San Marco, Fra Bartolomeo, who had become a member of the Dominican Order in the Monastery of Prato in 1500, after being deeply affected by the stern spirituality of Savonarola. Here several important works have been collected, notable not only for the development of the Italian Renaissance in the classical sense but also because of their ties to the political vicissitudes of the city of Florence.

Fra Bartolomeo

Florence 1473–1517

St Catherine of Alexandria

Fresco on tile, 47 x 35 cm
Inv. 1890 no. 8517

This small fresco part of a series of seven murals painted on roof tiles which came from the Dominican Ospizio della Maddalena on the outskirts of Fiesole where Fra Bartolomeo stayed on many occasions and where he died in 1517. The unusual support was designed to facilite the mounting of these paintings in the wall, perhaps in monks' cells, almost in imitation of the frescoes Fra Angelico had painted in the San Marco dormitories.

Fra Bartolomeo

Madonna and Child with St Anne and Other Saints
(Signoria Altarpiece)

Panel, 444 x 305 cm
Inv. 1890 no. 1574

The panel was commissioned by Pier Soderini, Gonfaloniere of the Florentine Republic, in 1510, to complete the decoration of the Sala del Gran Consiglio, the meeting place of the republican parliament after the exile of the Medici in 1494. Six years earlier Leonardo (1452–1519) and Michelangelo (1475–1564) had frescoed their masterpieces here to celebrate the regaining of civic liberty.

The complex iconography of the altarpiece was described by Vasari and, according to him, the painting depicts the ten patron saints of the city and the saints of the days on which Florence had won victories, joined together in a *Sacra Conversazione* on the mysteries of the Immaculate Conception, represented in the centre by St Anne and the Madonna and Child. The altarpiece had reached its preparatory stage – the state we see it in today – by January 1513, but the fall of the Republic had robbed it of the purpose for which it had been commissioned. After Fra Bartolomeo's death it was moved to the Church of San Lorenzo but during the third Republic (1527–1530), it was once again triumphantly reinstated in the Sala del Gran Consiglio. By 1728 it had passed into the collection of the Grand Duke Ferdinando de' Medici and in 1774 it was housed in the Uffizi. From there it was moved to the San Marco Museum in 1924. The liveliness of the illustrated *Conversazione* and the size of the figures in this grandiose composition, depicted against the background of a classical exedra, conformed admirably to its proposed location – a theatre of animated debate.

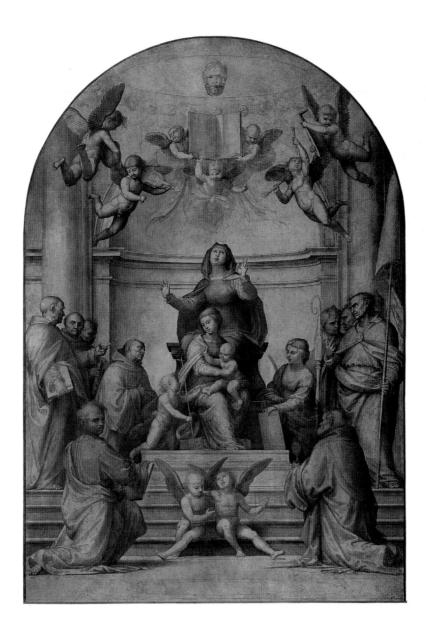

Fra Bartolomeo

Madonna and Child

Fresco on terracotta, 63.5 cm diameter
Inv. 1890 no. 8521

This fresco was painted with great chromatic
refinement using luminous, delicate hues. It originated
in the Monastery of San Marco and was painted on a
brick tondo similar to the Ospizio delle Caldine tiles.
It belongs to Fra Bartolomeo's later period and was
painted after 1514, that is after the painter had
returned from Rome, where he may well have visited
the studio of Raphael (1483–1520) and seen the
Madonna della Seggiola (Florence, Galleria Palatina)
and the *Madonna dei Candelabri* (Baltimore, Walters Art
Gallery), both of which appear to have influenced the
artist's composition.

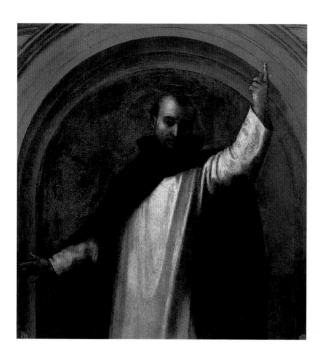

Fra Bartolomeo

San Vincenzo Ferreri

Panel, 130 x 116 cm
Inv. 1890 no. 8644

This panel has been reduced in size by being cut at
the base and on both sides. It dates from the second
decade of the sixteenth century and, according to
Vasari, was painted for the Church of San Marco and
placed above the door leading to the Sacristy. A small
tondo portraying *Christ the Judge and Small Angels piping*
once formed part of the panel and would have
completed the traditional iconography that usually
accompanied the saint, but its position in relation to
the tondo remains unknown. Recent restoration has
improved the visibility of the panel, which is in a very
poor state of preservation, and has enabled the
rediscovery of the monumental architectural niche
forming the background from which the powerful,
severe figure of the saint emerges.

The Room of the Banner

(THE ALESSO BALDOVINETTI ROOM)

This small room once formed part of the domestic offices of the original monastery. It was adjacent to the old kitchen, now the Fra Bartolomeo Room, and the fine old stone basin inserted into the wall is surviving evidence of its previous use. It was connected to the Chiostro della Spesa and to a mezzanine storeroom.

The room takes its name from an old attribution of the banner with *Christ on the Cross adored by St Dominic* to Alesso Baldovinetti (*c.*1426–99), and it houses a collection of works by various artists from central Italy loosely connected to Fra Angelico either chronologically or geographically. Further paintings have yet to be definitively attributed.

Paolo Uccello

Florence *c.*1397–1475

Predella with *Pietà between the Madonna and St John the Evangelist*

Panel, 85 x 100 cm
Inv. San Marco. Comune dep. inv. no. 192

Two small but significant paintings, unfortunately much damaged, by Paolo Uccello are displayed in this room, which is currently undergoing refurbishment. One of these, an ogival detached fresco, came from the house of Antonia di Giovanni del Beccuto, the artist's mother. It was salvaged during the course of the nineteenth-century demolition of Florence's old city centre. It depicts a *Madonna and Child* and is considered to be a youthful work.

The other panel, inscribed with the date 1452, formed part of an *Annunciation* that was stolen at the end of the last century from the Oratorio dell'Annunciata di Avane and which has never been recovered. The two lateral figures are rendered with great pictorial refinement and inspired inventiveness, both in the three-quarter stance of the Virgin, set out on curvilinear rhythms, and in the broken-up rhythms which characterize the figure of St John, which is terser and sharper in its facial lines.

Benozzo Gozzoli

Florence *c.*1420/25–Pistoia 1497

Predella with *The Mystic Marriage of St Catherine, Christ in the Sepulchre with St John and Mary Magdalen, St Anthony Abbot and St Benedict*

Panel, 21 x 221 cm
Inv. 1890 no. 886

This painting was originally in Santa Croce, where it formed the predella of an as-yet unidentified altarpiece. In 1847 its ownership passed to the Gallerie Fiorentine and it was subsequently displayed in the Museum of San Marco. This is the only panel by Gozzoli to be kept in the place where the artist received his training, during a long period of collaboration with Fra Angelico in decorating the cells of the dormitories. It can be dated to the artist's Florentine period when he frescoed the Cappella dei Magi in the Medici Palace in 1459, to the work in which it is stylistically similar. It therefore dates from between 1459 and 1463. The scene is painted with delicate mastery and both the figures and the composition appear to have been influenced by examples of Fra Angelico's work, but interpreted in a more linear manner, particularly in the face of St Catherine, exquisitely painted, and lacking the usual pathos dictated by convention.

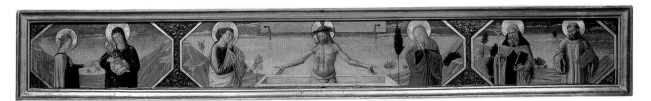

Francesco Botticini

Florence 1446–98

Christ on the Cross adored by St Anthony

Canvas, 276 x 147 cm
Inv. San Marco Cenacoli, 1915, no. 277

The painting was originally in the chapel of
St Antonino in the Church of San Marco. From there
it was moved to the monks' cemetery and since 1907
it has been displayed in the Museum. The painting
is in a poor state of repair and difficult to decipher,
worn by long years of being used as a banner, its
original function.

For a long time it was attributed to Alesso
Baldovinetti, and indeed the room is named after
Baldovinetti on account of it, but it now appears
without doubt to be a youthful work by Botticini. The
annals of the monastery record that it was painted in
1483 by Pollaiolo (1433–98) "at the command of the
Prior, Francesco Salviati".

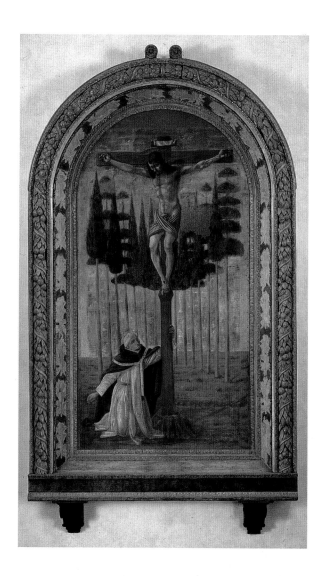

Attributed to Piermatteo da Amelia

active 1467–1503/08

Madonna and Child

Panel, 64 x 45 cm
Inv. 1890 no. 2199

Among the fifteenth-century panels from central
Italy in this room is this *Madonna and Child*, bought in
1882 from the Florentine antique market as being by
Fiorenzo di Lorenzo (*c.*1440–*c.*1525). It has been attrib-
uted, but without any great certainty, to Piermatteo
da Amelia, a figure who has only recently been
historically identified and who is thought to be
responsible for a group of works previously attributed,
by convention, to the "Maestro dell'Annunciazione
Gardner". He was a pupil of Filippo Lippi (1406–69)
and was active in Perugia during the 1480s where
elements from northern Italy, Tuscany and Urbino
seem to have fused. The artist then seems to have
developed a style closer to Verrocchio (*c.*1435–88)
and Piero della Francesca (*c.*1410/20–92).

The small panel has an old-fashioned gold back-
ground, presumably ordered by the commissioner,
and the iconography is reminiscent of the so-called
"Madonne alla Finestra", widespread in Umbria thanks
to Verrocchio's example. The bold strokes sketching
the outlines bring the solidity of the volumes into
strong relief. Above all a refined elegance of detail
stands out, particularly with certain details: the hands
of the Virgin, the ribbon that winds playfully around
the Child and the delicacy of the decoration on the
fabric and along the border of the robe and the texture
of the background.

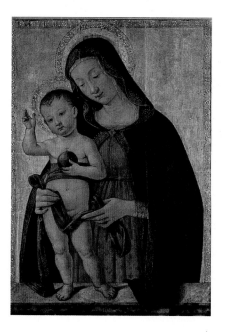

The Chiostro della Spesa

The domestic offices lead outside into a small fifteenth-century cloister, the Chiostro della Spesa, where there was once a well which supplied water for the dormitories on the first floor. One entire span was taken up by a spiral staircase, which has not survived, which went from the basements to the cells. In the seventeenth century the Cloister was crowned by a small loggia. Today it leads on the west side to the Lapidarium downstairs and a passage connects it to the Cloister of St Dominic, to the Small Refectory and to the Foresteria.

Lapidarium

At the moment the Lapidarium is closed to the public, with the exception of scholars, who apply in advance. The vast area, used as a Lapidarium for the museum, stretches across the basement rooms around the cloister of St Antonino and underneath other rooms.

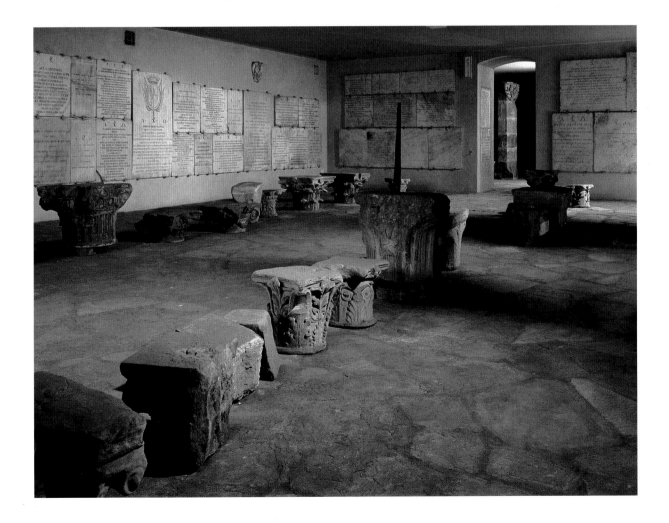

The Small Refectory

From the north side of the Cloister of St Antonino a corridor leads to the second cloister, built by Michelozzo for San Marco and dedicated to St Dominic. It can be seen through a glass door: since it is still used by the Dominican community it does not form part of the Museum. From here a large staircase leads to the dormitory floor and to the Small Refectory.

This room was perhaps part of the domestic offices of the original monastery but by the end of the fifteenth century it was being used as a refectory reserved for smaller or more select groups than those dining in the Large Refectory, chosen from the monks and pilgrims lodging in the Pilgrims' Hospice. In fact the room is adjacent to the Foresteria rooms. It is decorated with a great fresco depicting the Last Supper by Ghirlandaio and his workshop.

Domenico Ghirlandaio

Florence 1449–94

Last Supper

Fresco, 420 x 780 cm

Ghirlandaio, who frescoed this *Last Supper* for San Marco shortly before 1480, was the owner of a busy workshop much in demand by the great Florentine families. The fresco reflects the iconography usual during the second half of the fifteenth century in which Florentine paintings of the Last Supper had replaced the Crucifixion as a suitable theme for refectory decoration. Accommodating the elegant architectural divisions created by Michelozzi, Ghirlandaio has painted the apostles on a perspective plane which creates the illusion of a room within a room. Recent restoration work has fully revealed the studied balance between light and shadow; the indirect sunlight shines from the left, flowing over the table-cloth on to the figures and objects. The work is rich in realistic detail, typical in Ghirlandaio's painting. He was unsurpassed as a chronicler of the tastes and characters of his contemporaries and here adds details such as the comestibles on the table, animals and plants that enhance the symbolic value of the painting as a Christian artefact. The cat is a diabolic animal (an enemy of the *Domini canes* or hounds of the Lord), the peacock is a symbol of the Resurrection, the lilies and the roses are symbols of purity and the blood of martyrdom respectively, the palm tree is a further allusion to martyrdom and the cypress trees to death.

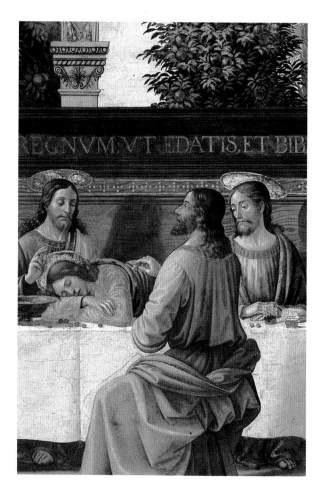

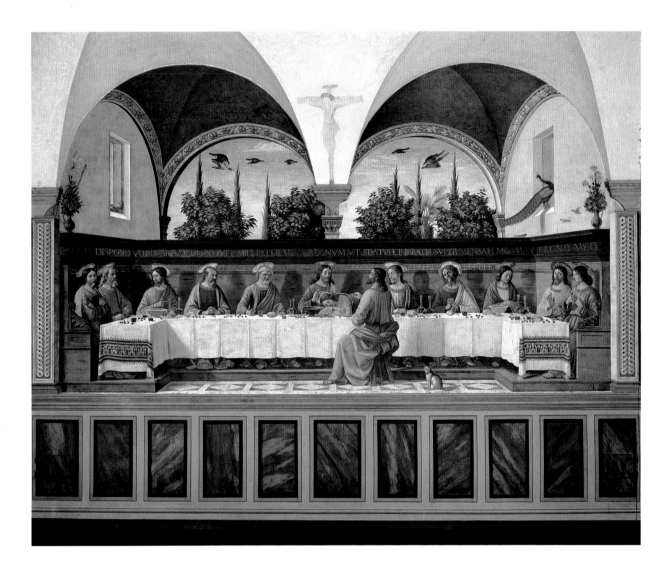

Antica Foresteria
(Old Guest Quarters)

The old guest quarters are reached from the Small Refectory through a passage that connects with the Chiostro della Spesa. Six rooms lead off a wide corridor; they probably formed part of the medieval complex on which Michelozzi constructed the Library during the fifteenth century. A large proportion of the fragments that survived the demolition of the old Florentine city centre at the end of the nineteenth century are collected here. They are mostly stone fragments, but there are also some detached frescoes which, together, constitute the "topographical section" of the San Marco Museum, inaugurated in 1898.

Above the doors to the rooms there are eight lunettes depicting Dominican Saints. Five of these are by Fra Bartolomeo but the other three were repainted during the late eighteenth century, when, according to contemporary documents, the whole area around the guest quarters was restored.

Andrea di Nofri

1387/88–1451

Doorway from the Arte dei Rigattieri, Linaioli e Sarti

Stone and inlaid wood, 463 x 329 x 40 cm
Inv. San Marco. Raccolte comunali, 1925, no. 47

This is one of the most beautiful and imposing artefacts in this section of the Museum and it testifies to the original splendour of the buildings of which it once formed part. The doorway was carved by Andrea di Nofri in 1414 and painted in 1434 by Pietro di Lorenzo (second quarter of the 15th century) for the powerful Arte dei Rigattieri, Linaioli e Sarti (Cloth, Linen and Silk Makers' Guild), the same guild that commissioned the monumental tabernacle, painted by Fra Angelico, which is now on display in the Pilgrims' Hospice. On the lintel six pear-shaped shields have been carved on a background of a field of Anjou lilies. From the left they represent: the Guild of Rigattieri, Linaioli e Sarti, the Captain of the People, the Florentine Church, the Florentine Republic, the Guelph Party and again the "Rigattieri".

Florentine Workmanship

late 14th–early 15th century

Wall-Painting Fragments: Detached frescoes

Inv. San Marco. Raccolte comunali, 1925, nos 241, 242, 266, 272, 274;
Esp. nos 36, 38

These consist of seven fragments of wall painting displayed in various rooms of the guest quarters; they came from houses belonging to the Pescioni or Teri families. The decorative scheme consists of an alternating pattern of blue panels with chivalrous scenes and red squares with heraldic crests. The former have been identified tentatively, given their poor state of preservation, as depicting episodes from the story of Tristan and Isolde.

Giambologna

Douai 1529–Florence 1608

Coat of Arms of the Vecchietti Family

Stone, 235 x 100 cm
Inv. San Marco. Raccolte comunali, 1925, no. 76

This is the larger of the two heraldic crests which Bernardo Vecchietti commissioned from Giambologna for his palace. They date from 1578 when work on the new façade began.

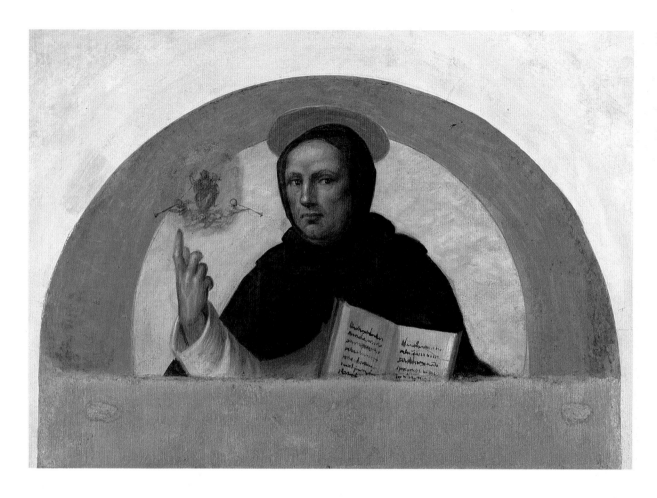

Fra Bartolomeo

Florence 1473–1517

San Vincenzo Ferreri

Fresco, 74 x 120 cm

The image of San Vincenzo Ferreri has been painted against a simulated stone background together with, according to the usual iconography, an image of the Apocalyptic Christ with two piping angels. It is one of five images of Dominican saints that Fra Bartolomeo painted in the five lunettes above as many doors of the guest quarters around 1511 to 1512. It immediately invites comparison with the figures of saints painted by Fra Angelico above the doors in the Cloister of St Antonino. Fra Angelico's are severe iconographical representations of doctrine but Fra Bartolomeo's are vivid and occasionally highly characterized, such as this one showing San Vincenzo making a forceful gesture, and with a penetrating gaze.

The Cloister of the Silvestrine Monks

A small room in the guest quarters leads into the Corte del Granaio, so named because it was originally used to house the Monastery's grain store where today further architectural fragments from the demolition of the old Florentine city centre are on display. From here the last remaining vestige of the medieval complex, the fourteenth-century Cloister built by the Silvestrine Monks, can be reached. It contains a collection of coats of arms and tomb inscriptions which were moved to San Marco in 1894. They date from the thirteenth to the eighteenth century and were removed from the ancient burial-ground of San Pancrazio, one of the oldest Florentine monastic settlements, dating from the tenth century. Here tablets in memory of families from all the social classes are variously represented.

The Silvestrini cloister, XIV sec., with tomb inscriptions and coats of arms, from St. Pancrazio church in Florece

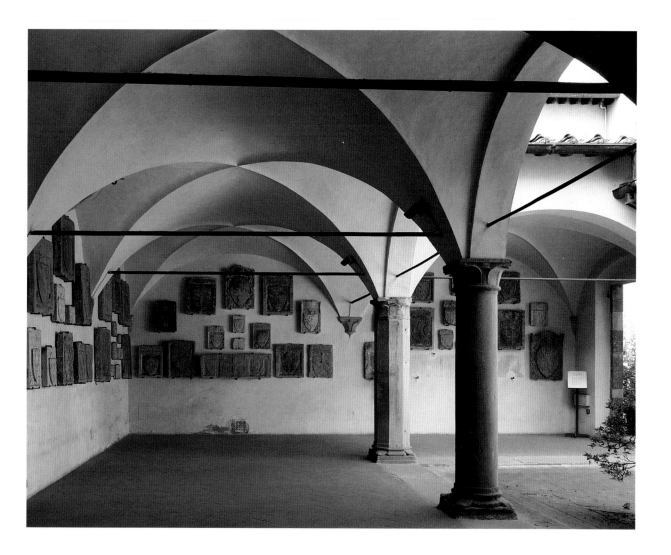

Giusto di Giovanni da Settignano and Clemente di Matteo da Santa Maria a Pontanico

Funerary Monument of Vincenzo Trinci

Marble, 105 x 174 x 40 cm
Inv. San Marco e Cenacoli, 1915, no. 382

Vincenzo commissioned two sculptors to carve his monument in 1489 but they have not been definitively identified. Reassembled here, it forms part of the original monument which was continually moved around the interior of the Church of San Pancrazio, its original home, and subsequently relocated in various other places. The effigy of the deceased rests on an unusual couch lying on a frame raised up from the main body of the tomb. On the lower section there is an epitaph flanked by two shields bearing the Trinci family's coat of arms.

Early Christian Art (5th century) and Florentine Workmanship (14th century)

Fragment of a Sarcophagus with the Temperani Family Coat of Arms

Marble, 40 x 216 cm
Inv. San Marco e Cenacoli, 1915, no. 381

This is the front of an early Christian sarcophagus on which two episodes from the life of Jonah have been carved. In the centre there is a pear-shaped shield bearing the coat of arms of the Temperani family. This unusual artefact came from the crypt of the Church of San Pancrazio. The tomb was later used to inter a member of the Temperani family who added the shield in the centre and, possibly, the two fragmentary heads on either side.

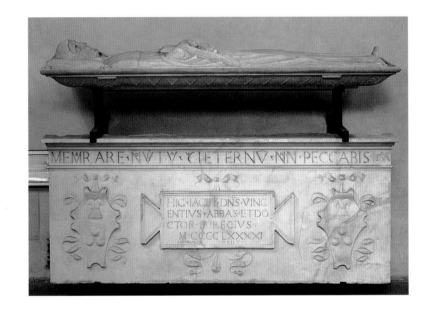

First Floor
The Dormitories

From the corridor connecting the two main cloisters, a staircase leads to the first floor where the dormitories are situated. At the top of the stairway the visitor is faced with the *Annunciation*, one of the three frescoes that Fra Angelico painted on the walls of the corridors rather than inside the cells themselves. The *Annunciation* is an introduction to the spirituality of the place – a place reserved for meditation and for the monks' prayers.

The dormitories are arranged around three corridors bordering the Cloister of St Antonino: the first and the third, on the eastern and on the northern sides of the building, have cells on both sides; the southern corridor, which looks over Piazza San Marco, has a single row of cells on the inside wall, facing the Cloister. According to Lapaccini's Chronicle (SEC. XV), the construction of the dormitories began in 1437 with the building of the first corridor above the old Refectory, which had formed part of the original monastic complex built by the Silvestrine monks. The Refectory had been preserved and incorporated, together with the Church, into the new complex whose restructuring and enlargement had been entrusted to Michelozzo di Bartolomeo (1396–1472). Recent accidental discoveries have revealed fourteenth-century wall paintings on the outer walls of the second dormitory on the corridor on the south side, below the present floor level, forming what would have been an extension to the Pilgrims' Hospice below. This has brought to light certain elements which have led to a better understanding of the alterations carried out on the building, beginning with those done in the fifteenth century, and allowed a more precise insight into the nature and design of the work carried out by Michelozzo. Early authorities had maintained that the medieval buildings had been demolished and entirely rebuilt but, in fact, Cosimo de' Medici's chosen architect kept the existing structure in many places, reinforcing it and elevating it to build the dormitories on the first floor and enlarging it for the construction of the great Library.

The current appearance of the building, however, owes much to adaptations and restorations carried out over successive centuries. An imposing wooden truss-beamed roof covers the 43 cells on three corridors. Today the cells have individual vaulted plaster ceilings, but these may not have originally existed, or they may have had flat roofs.

Each cell is decorated with a fresco, with the exception of three at the end of the second corridor, which in the fifteenth century were the "Vesteria del Giovanato" and were later occupied by Girolamo Savonarola. Most of the frescoes were painted by Fra Angelico with the assistance of his workshop between 1439 and 1445 and perhaps completed, after an interval, during Fra Angelico's last period in Florence, between 1450 and 1452, before his final move to Rome.

In its entirety, the cycle of murals which make up the decoration of the cells is unique in Western figurative painting. The grand scope of

the scheme takes on the character of a marvel, considering the high standard of execution and the originality of the cultural and figurative purpose – although the paintings were destined almost exclusively for the monks in aiding their private meditations. The closed nature of the Monastery further excluded these frescoes from cultural consciousness and discussion for centuries, and it was only after the secularization of the Monastery in 1869 and its transformation into a museum that the frescoes have become part of our cultural heritage, and, in some cases, an essential element of the collective imagination. Their recovery in historical and critical terms has made a substantial contribution to a better understanding of the artist. They have helped to affirm Fra Angelico as a precocious and exceptional interpreter of the new language of the Renaissance, initiated by Masaccio (1401–28) in painting, and as a great painter of the crucial period between 1430 and 1450, between Masaccio himself and Piero della Francesca (*c.*1410–92).

The entire cycle was accomplished by Fra Angelico, or under his direct supervision whenever the actual execution of the painting was carried out by others. Represented are episodes from the life of Christ, but not arranged in any programmed order. St Antonino, prior of the Monastery of San Marco between 1439 and 1444, was probably the instigator of the themes depicted; following his precepts the Dominican Rule (*Constitutiones Domenicanae*) was made manifest, creating images charged with profound religious feeling.

This would explain the repetition of certain subjects in many variations, principally the Crucifixion accompanied by St Dominic, sometimes joined with the Virgin or another saint. In each cell a relatively large fresco, in proportion to the size of the room, replaced the usual wooden crucifix or Marian icon. Some of the most important figurative documents of the Italian Renaissance, in terms of perspective

The *Annunciation*, detail from the dormitory corridor.

and treatment of light, were provided almost exclusively for the individual occupants of the cells, for contemplation and meditation. Technically, the decision not to use gold leaf and azurite in any of the frescoes, except those reserved for Cosimo de' Medici for his private meditations and those frescoes used for prayer in the public spaces in the corridors, constituted a further reflection on "poverty", a unifying theme of the great mural cycle.

The sequence of the images in the cells reflects a criterion of definite importance – possibly that of the role of the monks who occupied them. The most important frescoes, both artistically and from the point of view of their subject matter, are those painted in the cells of the first (east) corridor. Among these, the frescoes in the cells on the outer wall are of greater importance than those in the cells facing the Cloister. Frescoes in the former depict scenes from the life of Christ and almost without exception they can be directly attributed to Fra Angelico. In these, symbolism and allusion rather than narrative are prevalent. On the Cloister side, the dominant theme is the Passion and the sacrifice of Christ on the Cross, the latter subject often repeated many times with minimal iconographical variations, limited to the presence of differing Dominican saints or figures differing in their devotional poses. Recent critics have tended to credit Fra Angelico with the general conception of the compositions but, with certain exceptions, to attribute the execution to the workshop. In particular, the progress of a promising assistant to the painter-monk, Benozzo Gozzoli (*c.*1421–97), who was apprenticed to the San Marco workshop, is apparent.

Decoration of the cells continued along the third (north) corridor, alongside the Cloister. Paintings in cells 31 to 37, relating to the Passion of Christ, take on a narrative aspect and are a celebration of story-telling. The compositions become more elaborate, the scenes are crowded with characters and they are enriched by suggestive back-ground landscapes. Notwithstanding the assistance of his workshop in the general design or in various single episodes, critics agree in recognizing the hand of Fra Angelico. Among the most important of his assistants was Gozzoli, who was responsible for a number of frescoes depicting the Crucifixion on the external walls of the corridor and of the series of frescoes where the only characters are Christ and St Dominic painted on the south wall, reserved for the cells of the novitiates. Gozzoli's prominent role in the workshop carrying out the decorations in San Marco is confirmed by the fact that he was assigned the greater part of the decoration of the two rooms, the cell and vestibule to the side of the Library, reserved for Cosimo de' Medici, patron of the fifteenth-century reconstruction of the Monastery.

The entire cycle was the subject of major restoration from 1975 to 1983.

Fra Angelico

Vicchio del Mugello *c.*1395–Rome 1455

Annunciation

Fresco, 230 x 297 cm

This is one of the most famous (and frequently
reproduced) frescoes by Fra Angelico which still greets
the visitor at the top of the staircase leading to the
dormitories, although the staircase itself has been
many times modified over the centuries. The subject,
frequently painted by the artist with few variations,
here achieves heights of singular elegance; the serene
architecture of the loggia reflecting the creations that
Michelozzo was constructing on the floor below. The
rigour of the composition and its handling of space,
which reach new heights of poetry in its play on light
and shadow on the building, is not lost in secondary
episodes of the narrative, such as the depiction of the
expulsion of Adam and Eve from the Garden of Eden
that appears on the left of the loggia in all the other
versions of the same subject. The aim is to represent
only the bare image, giving weight to movement and
to the spiritual concentration of the figures. The close
similarity to Michelozzo's architecture would indicate a
date prior to Fra Angelico's Roman period.

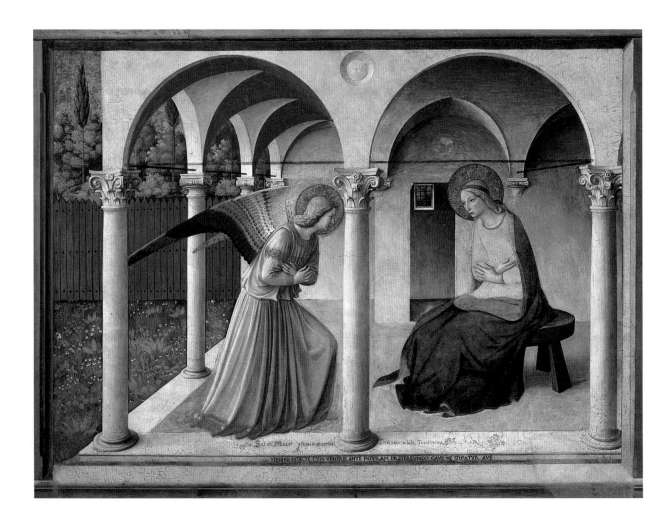

Fra Angelico

Christ on the Cross adored by St Dominic

Fresco, 237 x 125 cm

Here the subject of the fresco symbolizes the practice of Dominican prayer. In the same way that an analogous painting greets the visitor on entering the monastery in the Cloister of St Antonino, the fresco here was a constant reminder to the monks who would gather in front during collective worship, to obey the monastic precepts.

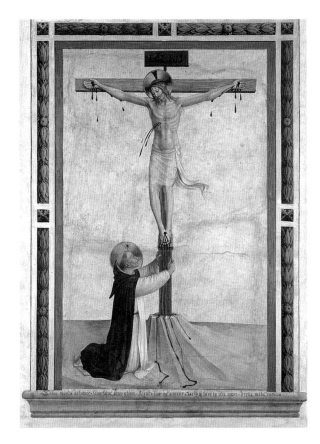

First Corridor (LEFT-HAND SIDE)

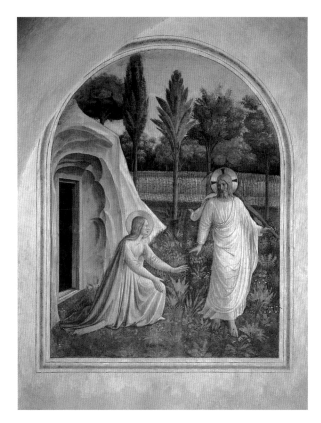

Fra Angelico

Noli Me Tangere (Cell 1)

Fresco, 166 x 125 cm

Critics agree that the eleven cells on the first corridor are mainly and in some cases exclusively the work of Fra Angelico. In the first cell the fresco depicts a radiant apparition of Christ, covered in a white shroud, in the guise of the gardener, while Mary Magdalen, kneeling, attempts to touch him. The colouring is luminous and transparent and the few colours are treated with enormous subtlety. Although this painting is traditionally considered to be the initial fresco in the decorative cycle of the dormitories, the absence of a saint or a Dominican monk in the mystic images (a constant presence in all the succeeding cells) and the painting of the haloes as if they were golden discs glittering with reflected light, as well as the liquid transparency of the colours, have raised doubts whether this was the first fresco to be painted, favouring the argument that it was a later work.

Fra Angelico

Lamentation over the Deposed Christ (Cell 2)

Fresco, 184 x 152 cm

The compositional scheme of this fresco has visual analogies with the panel that the painter worked on almost simultaneously, on display in the Pilgrims' Hospice, which came from the Church of Santa Maria della Croce al Tempio. This fresco, however, was for the private contemplation of the monks, to which the figure of St Dominic on the left alludes, and thus the fresco is reduced to its essentials, the minimum number of characters in a desolate landscape which highlights the marble, prismatic presence of the sarcophagus and intense psychological concentration on supreme Christian compassion dominates all.

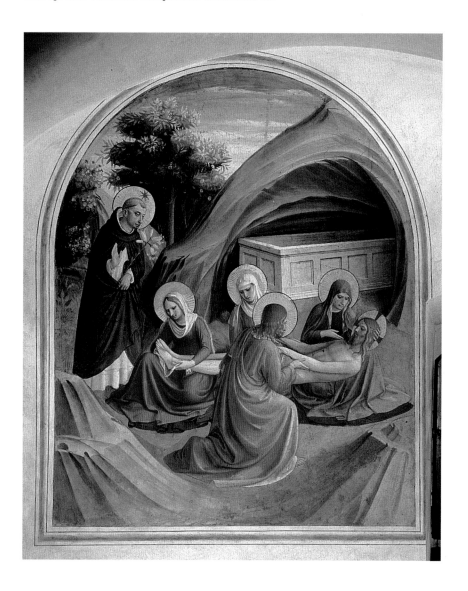

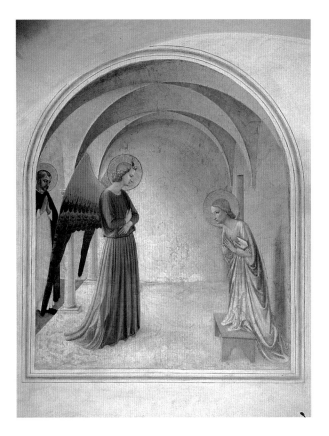

Fra Angelico

Annunciation (Cell 3)

Fresco, 176 x 148 cm

The sparseness of the architectural setting, a vaulted cloister supported by slender Ionic columns – intensified by the perspective created by the curved shape of the frame which inwardly projects the sequence of arches – renders this, through its simplicity of form, the most spiritual and mystical of all the many Annunciations painted by Fra Angelico. The pure apparition, at which St Peter Martyr is present as a silent onlooker and mediator for the vision, is resolved with the most brilliant but narrow range of colour which achieves heights of suggestiveness in the robe of the Virgin, here lacking the usual finishings in azurite.

Fra Angelico

Nativity (Cell 5)

Fresco, 177 x 148 cm

The apparent simplicity of this composition, almost fourteenth-century in style, is actually based on a rigorous and modern scansion of planes on diagonals which intersect in the central figure of the reclining Child, creating an exact circularity of spaces. Perhaps for the first time the hand of one of Fra Angelico's assistants is discernible in the group of angels praying on the stable's roof.

Fra Angelico

Transfiguration (Cell 6)

Fresco, 181 x 152 cm

The fresco is bathed in radiance shining out from the
figure of Christ, and reaches unexpected heights in its
exceptional resolutions of light, such as the effect of
backlighting the foreground figures. Christ rises up
imposingly against a background of transcendent light,
wrapped in a snow-white robe pleated with folds of
sculptural solidity. On either side are the delicate
figures of the Virgin, the silhouette of her profile
drawn with extreme elegance, and St Dominic,
thoughtfully contemplating the scene.

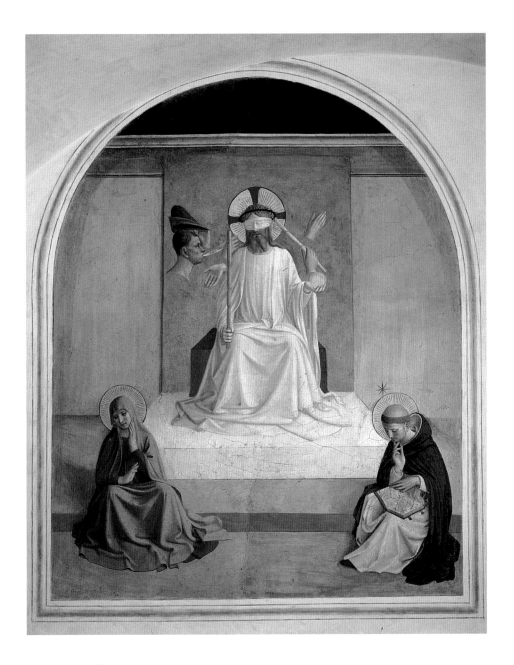

Fra Angelico

The mocking of Christ with the Virgin and St Dominic
(Cell 7)

Fresco, 187 x 151 cm

In clearly defined spatial divisions in parallel planes
the composition invites reflection on the mocking of
Christ where the Virgin and St Dominic, engrossed in
his reading and absorbed in meditation on the
religious mystery, act as mediators. The fresco stands
out in the entire cycle on account of its limpid,
crystalline luminosity, revealing the painter's growing
interest in rendering light effects. The transparency of
the pigments is apparent in the blindfold covering the
eyes of Christ, which leaves his features visible.

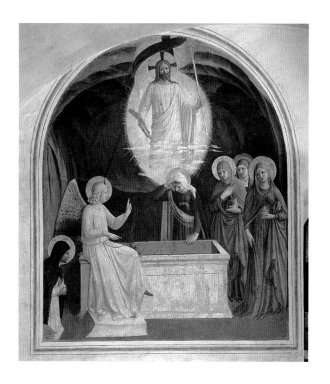

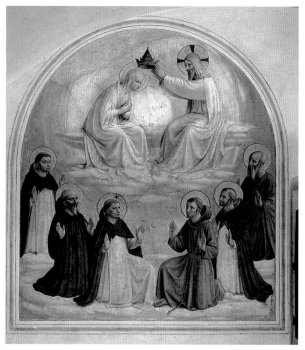

Fra Angelico and Assistant

The Marys at the Sepulchre (Cell 8)

Fresco, 181 x 151 cm

In terms of quality this is one of the most important
frescoes in the cycle, notwithstanding the frequent
help of an assistant, identified by all the critics as
Benozzo Gozzoli, who was responsible for the group
of the three Marys at the right of the tomb, who do
not attain the spiritual tension found in Fra Angelico's
figures. The luminous vision of the Risen Christ is set
against the sculptural quality of the angel. This angel,
shaped by a crystalline light which flows over and
defines his form, is summoning the Virgin from the
Sacellum of classical tradition, with infinite tonal
variety. In this sublime fresco Fra Angelico brings
together tonalities of colour and qualities of form in
a truly modern naturalistic manner: the spontaneity
of gesture and the daring foreshortening of the head.

Fra Angelico

Coronation of the Virgin (Cell 9)

Fresco, 171 x 151 cm

The composition of this fresco was inspired by the
harmony of the celestial spheres, and the central
episode, rendered with pure coloured light, evokes
medieval theological ideas. The hemicycle of the
founders of the great religious orders, with St Dominic
and St Francis in the foreground, opens up a series of
concentric planes on which the spatial structure of
the painting is built.

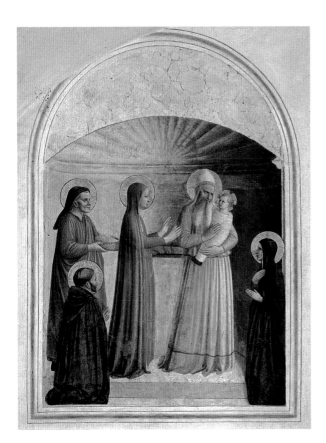

Fra Angelico

Presentation of Jesus in the Temple (Cell 10)

Fresco, 171 x 116 cm

Restoration work carried out between 1978 and 1983 led to important and unexpected results, such as the rediscovery, beneath red tempera overpainting, of the superb Renaissance architectural background consisting of a semicircular apse surmounted by a sadly fragmentary large, bowl-shaped vault in the form of a shell.

Second Corridor

Benozzo Gozzoli

Florence c. 1420/25–Pistoia 1497

Christ on the Cross adored by St Dominic (Cell 20)

Fresco, 173 x 103 cm

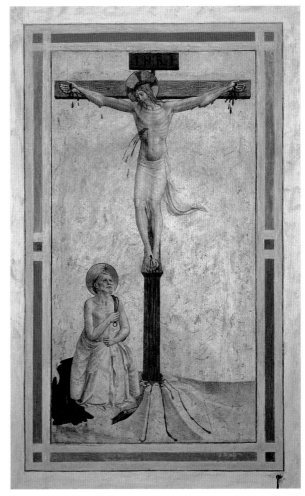

Savonarola's cells

At the end of the second (south) corridor are situated three cells which, during the fifteenth century, were in fact a double cell made out of the spacious and square-shaped "Vesteria del Giovanato". They were then altered into the state in which we see them today. Girolamo Savonarola lived in these quarters between 1484 until his capture in 1498, after which he was executed. The first of the rooms was used as a chapel, the second as a study and the third as a cell. Now they house a small collection of mementos, relics, sacred texts and objects that belonged to the friar.

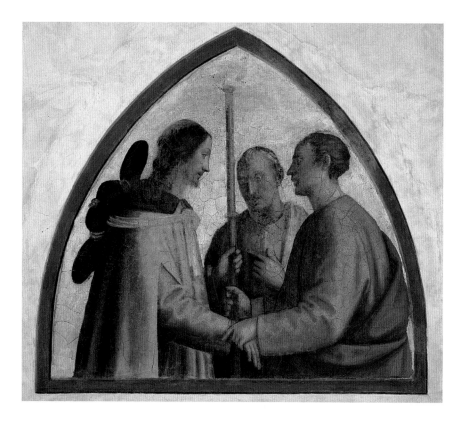

Fra Bartolomeo

Florence 1473–1517

Christ and Pilgrims on the Road to Emmaus

Detached fresco, 103 x 116 cm

It appears that this lunette was originally painted above a door leading into the Foresteria (guest quarters) of the Monastery of San Marco and moved here in 1872. It is similar in subject matter to the lunette painted by Fra Angelico above one of the doors that connects the Pilgrims' Hospice with the Cloister of St Antonino. Of the two pilgrims, the young figure on the right of the group is a portrait of Nicolaus Schomberg, prior of the Monastery of San Marco in 1506, the year the fresco was painted, and the central figure is usually identified as Sante Pagnini, Schomberg's immediate predecessor as prior of San Marco.

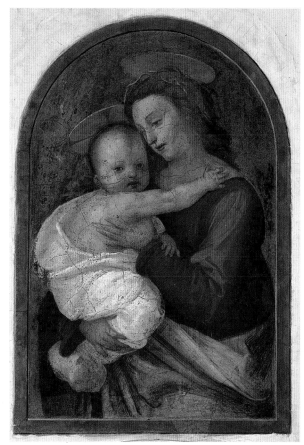

Giovanni Dupré

Siena 1817–82

Monument to Girolamo Savonarola

Marble, 246 x 175 x 45 cm
Bronze, height 57 x 61 x 35 cm

The monument, signed and dated, was placed in Savonarola's cell in 1873 with the intention of commemorating the monk according to a policy governed by strict Catholic ideology.

Fra Bartolomeo

Madonna and Child

Detached fresco, 120 x 78 cm

The fresco came from the Ospizio delle Maddalena alle Caldine and it was moved to San Marco in 1867; it had followed the same path as another fresco with an analogous subject that was brought here in 1707, where it can still be seen. According to a "memoir" of the Ospizio, this is generally thought to be one of the two frescoes painted in 1514. In any case it is stylistically derivative of Raphael's Florentine period (1504–8), when the two young painters embarked on a fruitful artistic dialogue.

Fra Bartolomeo

Portrait of Fra Girolamo Savonarola

Panel, 53 x 37 cm
Inv. 1890 no. 8550

This was presented to the Museum of San Marco by
Ermolao Rubieri in 1868 having once been owned by
Santa Caterina de' Ricci. Savonarola has been painted
with considerable psychological insight, defined by a
clear-cut profile with firm lips demonstrating the
force of his character. The style is a throwback to the
fifteenth-century tradition of Florentine full portrait
painting. His waxen face enclosed in a black cowl
intensifies the profound spiritual concentration
emanating from the portrait, which is completely
lacking in ornaments or background.

Bible

Membranous codex, 160 x 100 mm
Inv. San Marco e cenacoli, 1915, ms 482

Paduan (?) Miniaturist

13th century

St Paul

Painting on parchment, 150 x 170 mm

Two thirteenth-century antique bibles are kept in the
Museum of San Marco, and tradition has it that they
were annotated by Savonarola himself. They are two
manuscript membranous codices of unusual precision
and accuracy, notwithstanding their small size, rich
with illuminated initial letters, decorated with vegeta-
tion motifs and animals coloured with crushed azurite,
red-orange and pink pigments, with beads of gold
scattered here and there. Slender leaf-shoots often
terminate in heads of fantastic animals, characteristic
of the thirteenth-century figurative tradition. The
quality of the decoration, broadly similar given their
provenance, differs slightly and is superior in codex
481. Manuscript 482 has an initial letter decorated
with an image of St Paul, reproduced here.

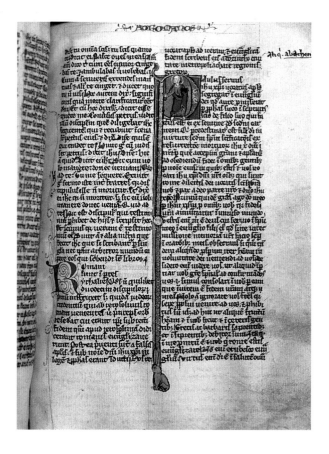

Florentine Painter

late 15th century/early 16th century

Piazza della Signoria and the Martyrdom of Savonarola

Panel, 100 x 115 cm
Inv. San Marco no. 477

This painting, of enormous historical interest, was presented to the Museum by Elenora Rinuccini Corsini in 1868. It is, in fact, a visual record painted almost at the same time as the events depicted took place: that is, the martyrdom of Savonarola and his two companions who in 1498 were hanged and burnt at the stake in Piazza della Signoria.

Giovanni Bastianini

Camerata, Fiesole 1830–Florence 1868

Portrait Bust of Girolamo Benivieni

Terracotta, 28 x 21 x 18 cm
Inv. 1918, no. 478

The bust was acquired in 1868, on the death of the sculptor, who had been well known for producing fakes of Renaissance sculpture, though he rarely made copies or variations, preferring new creations in the manner of the past. The head of Benivieni is a cast of the portrait bust of the poet, characterized by forceful and insistent realism, and it was displayed as an original fifteenth-century work in the Louvre in 1868. When Bastianini claimed that the work was his, the disclosure caused considerable polemic which ceased with his sudden, unexpected death.

First Corridor (RIGHT-HAND SIDE)

Fra Angelico and Benozzo Gozzoli

Crucifixion with the Virgin in Mourning (Cell 22)

Fresco, 144 x 81 cm

The fresco is an introduction to the themes illustrated in the novices' cells, where the subject, inspiration for the various modes of Dominican prayer, is repeated. The subject is the Crucifixion with St Dominic in varying attitudes, but here his role is taken by the Virgin in Mourning. The affinity between these frescoes and those in the second corridor is apparent from the shape of the fresco and the similarity in the frames which are all smooth with pink and pale green borders. The high quality testifies to Fra Angelico's vigilant supervision of their execution, which was largely carried out by the young Benozzo Gozzoli, his principal assistant at San Marco.

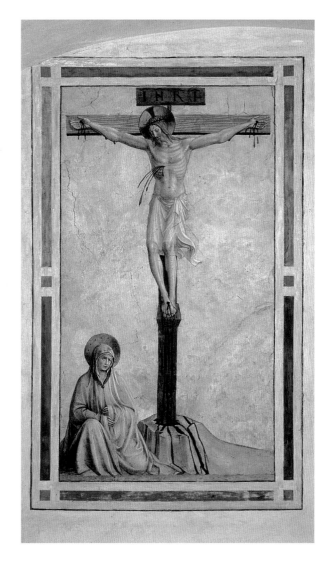

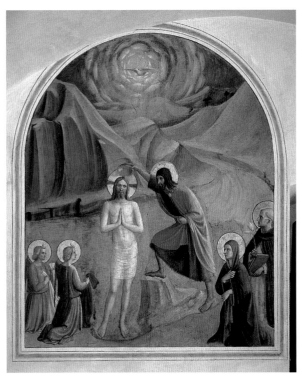

Fra Angelico

Baptism of Christ (Cell 24)

Fresco, 179 x 148 cm

This is one of the few frescoes in the dormitory with a dominant and detailed background landscape. The expansive loop of the river Jordan flanked by barren, lonely rocks, leads to the protagonists of the episode in the foreground. The colour range is distinguished by the use of unusual contrasts, such as the orange cloak of St John the Baptist on the emerald green background of the river which, coupled with the fluorescent cloud framing the dove of the Holy Spirit, create almost surreal effects in a rarefied atmosphere of suspense.

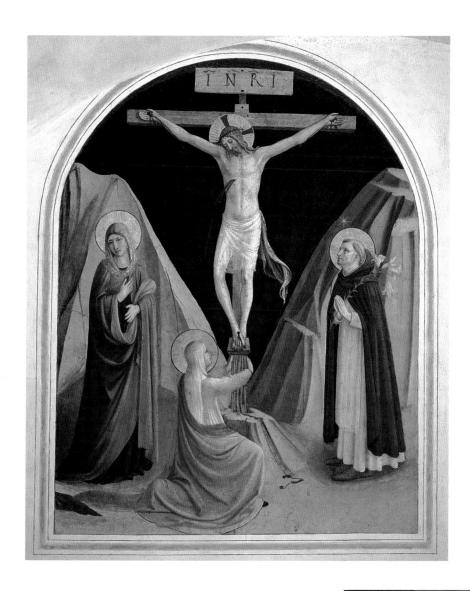

Fra Angelico and Assistant

Crucifixion with the Virgin, St Dominic and Mary Magdalen (Cell 25)

Fresco, 176 x 136 cm

The frequent crucifixion theme with two figures represented by the Virgin in Mourning and a Dominican saint on this side of the corridor is enhanced in this fresco by the presence of Mary Magdalen kneeling at the foot of the Cross. The fresco was mostly painted by an assistant, but the powerful and intensely expressive figure of St Dominic is entirely the work of Fra Angelico, painted in one "fresco day".

Fra Angelico

Madonna and Child enthroned with Saints Dominic,
Cosmas, Damian, Mark, John the Evangelist, Thomas,
Lawrence and Peter Martyr
(Madonna of the Shadows)

Fresco and tempera, 193 x 273 cm; 130 x 273 cm (lower border)

The fresco, painted on the wall leading towards the Cloister on the first corridor, is one of Fra Angelico's finest masterpieces. The technique of mixing fresco with egg tempera places it half way between the purer tradition of fresco and panel painting. Critics agree that it was the final work to be painted on the walls of the dormitories and was perhaps painted when the artist returned to Florence after leaving Rome where he had been between 1450 and 1452.

The composition follows Fra Angelico's often-repeated formula, used in many altarpieces painted after 1445, of delineating the scheme of a rectangular panel by creating depth in perspective. The figures are arranged against a curtain wall broken in the centre by a niche in which the Virgin is enthroned, surmounted by a bowl-shaped vault and a classical architrave. The curtain wall is intersected by slender pilaster strips protruding on the milky-white wall and casting faint shadows from the light coming from the left. The light source coincides with light that actually comes from a window at the end of the corridor. His extraordinary capacity to examine the effects of light permeates the whole fresco and he has created effects of metallic lustre in the apsidal vault and in the haloes, and light itself shapes the figures of the saints, in particular the group on the right, stylistically close to the characters he had frescoed in Rome.

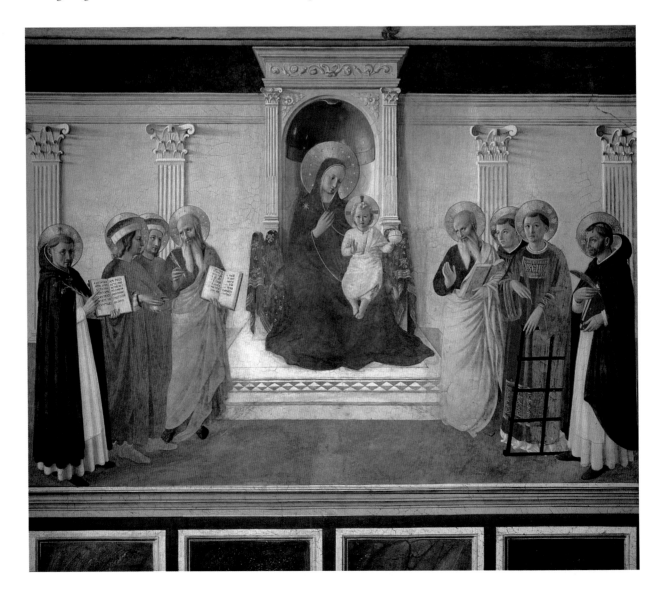

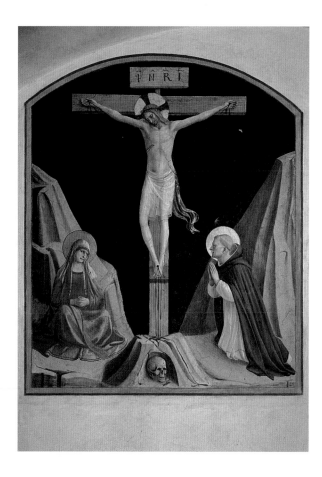

Fra Angelico
Crucifixion with the Virgin and St Dominic (Cell 30)
Fresco, 157 x 132 cm

Third Corridor

Fra Angelico and Assistant
Christ in Limbo (Cell 31)
Fresco, 183 x 166 cm

There is a tradition that this cell was occupied by St Antonino when, on his return to Florence in 1439, he became prior of the Monastery of San Marco and did everything in his power to revive it after it had passed to the Dominicans. He probably chose the theological scheme of the fresco cycle.

There is no reason to doubt the attribution of the composition of this fresco to Fra Angelico, but the feebleness in its execution and the simplification of the compositional scheme indicate that it was worked on by an assistant.

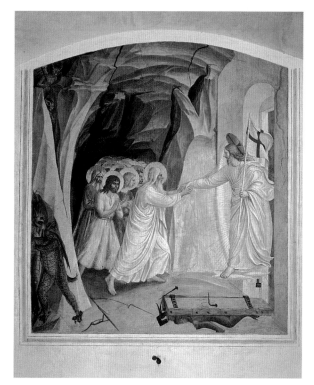

Fra Angelico and Assistant

The Betrayal of Jesus (Cell 33)
Temptation of Christ in the Desert (Cell 33a)

Fresco, 182 x 181 cm
Incomplete fresco, 163 x 54 cm

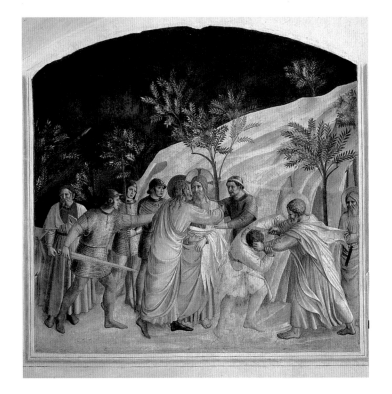

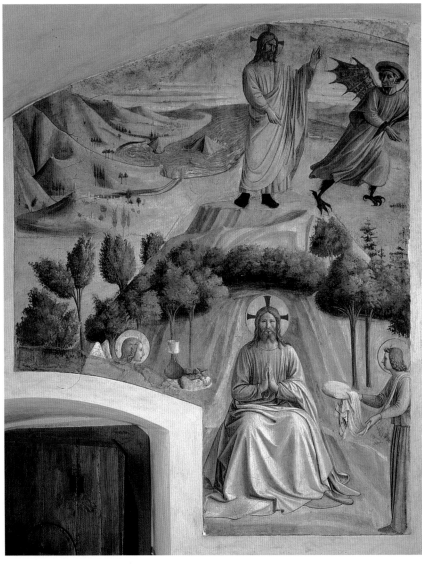

Fra Angelico and Benozzo Gozzoli
The Agony in the Garden (Cell 34)

Fresco, 177 x 147 cm

Critics agree in attributing the execution of this fresco to Benozzo Gozzoli: it has a difficult spatial dimension because of the distance between the scenes depicted, and with recent restoration it has re-acquired its original vivid colours.

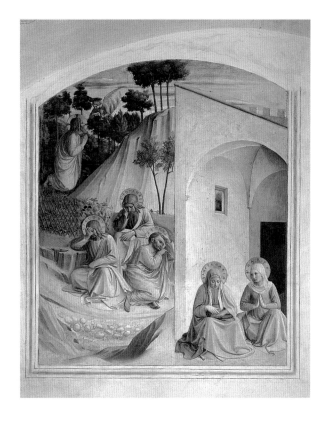

Fra Angelico and Assistants
The Last Supper (Cell 35)

Fresco, 186 x 234 cm

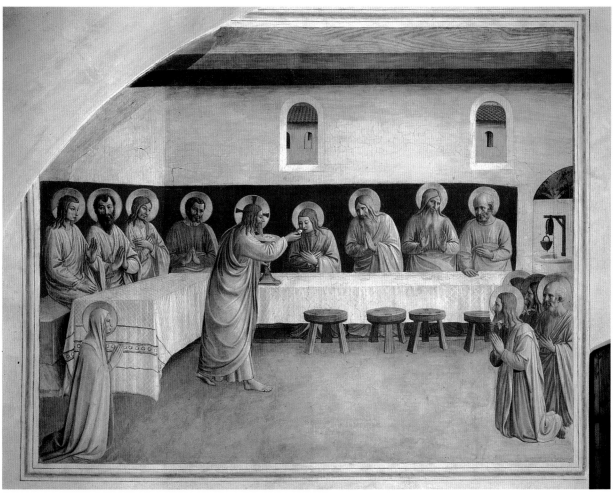

Fra Angelico and Benozzo Gozzoli

Crucifixion with the Virgin and Saints Cosmas, John and Peter Martyr (Cell 38)

Fresco, 152 x 112 cm

This cell and the next one were kept for the use of Cosimo de' Medici for private meditation. The theme of the Crucifixion with figures, the subject depicted in all the cells on this side of the third corridor, is again repeated.

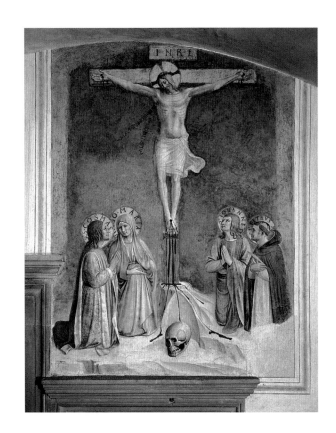

Fra Angelico

Crucifixion with Saints Mark (?), Dominic, Longinus, Martha and Mary (Cell 42)

Fresco, 196 x 199 cm

As in all the frescoes in this corridor's cells, with the exception of those painted in cells 38 and 39 which were reserved for the use of Cosimo de' Medici, the striking features are the limpid, crystal-clear atmosphere, the absence of any background or narrative detail which would intrude on meditations on the drama of the Crucifixion. This lent emphasis to the poses of the figures, intense yet restrained in their gestures, in a composition of extreme elegance. The colour quality approaches the luminosity of Fra Angelico's Roman frescoes, and the high quality of this fresco clearly points to the hand of Fra Angelico himself.

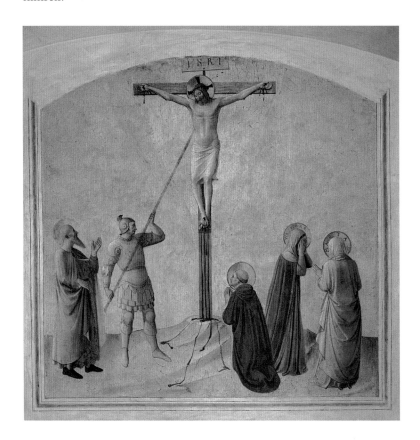

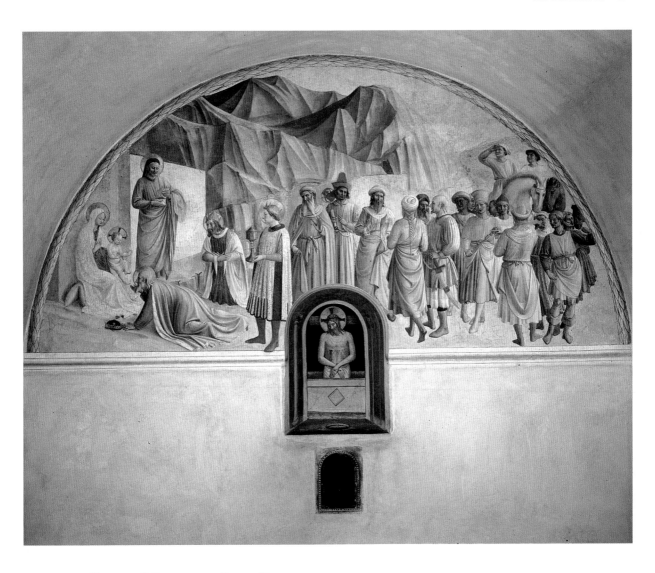

Fra Angelico and Benozzo Gozzoli

Adoration of the Magi (Cell 39)
Vir Dolorum

Fresco, 175 x 357 cm
Fresco, 86 x 60 cm

The fresco in the second cell used by Cosimo de' Medici, the *Adoration of the Magi*, occupies the entire end wall. Although the background is desolate, greater richness in detail is discernible due not only to the subject, but also, probably, to the person for whom it was done. The faint traces of azurite on the Madonna's mantle are an exception to the constant theme of poverty which inspires the entire dormitory decorations. The presence of unusual figures wearing exotic headdresses and clothing suggests these may have been portraits of people who had come to Florence in 1439 for the meeting of the Council. The insertion of a *Vir Dolorum* in the centre of the painting produces a *trompe l'oeil* effect that goes beyond the niche that frames the figure of Christ. Critics agree that Benozzo Gozzoli gave considerable assistance in the execution of this fresco, but a further collaborator painted the clumsier and more rigidly awkward figures.

The Library

The Library, one of the gems of Renaissance architecture, was built by Michelozzo on the upper floor of the Monastery to house the collection of codices for reasons of safety, for protection against the regular Florentine problems of flooding, and for convenient access from the dormitories. Its construction completed the enlargement and renewal of the Dominican complex.

It was probably built immediately after the corridors and the cells on the north side of the cloister of St Antonino, which would date it from around 1440. It became the prototype and model for all humanist libraries, and new libraries of this type became increasingly popular during the second half of the fifteenth century as a direct result of the Observance Reform which encouraged the foundation of schools and libraries. Among all the libraries which were founded by Cosimo de' Medici personally (in Venice, Fiesole and the Monastery at Bosco ai Frati outside Florence), it became the most famous and the best endowed. It was favoured by circumstance: on the prompting of Cosimo, the humanist Niccolò Niccoli bequeathed the greater part of his collection of classical texts, and they arrived following his death in 1437. The Library was classified by Vespasiano da Bisticci according to a system designed by Tommaso da Sarzana who became Pope Nicholas V. Cosimo himself gave a series of choirbooks, illuminated by Zanobi Strozzi (1412–68) and Filippo di Matteo Torelli between 1446 and 1454, to the Monastery. The Library stock was continuously enlarged over the succeeding centuries until 1810, when, on account of the suppression of the monasteries, its collection was divided up among the Biblioteca Laurenziana, the National Library and the Marucelliana.

Vaulted roofs on libraries became ever more popular, as they offered more protection against damage from frequent outbreaks of fire, but Michelozzo here was the first architect to build a library that was entirely vaulted. The enormous chamber is no longer cluttered with the original wooden fittings used to accommodate the books and now appears in its rigorous elegance and harmonious simplicity. The room is divided into three aisles covered by cross-vaults. The vaults on the two side aisles rest on one side on stone columns with Ionic capitals and on the other side on Ionic corbels, set in the wall. The central aisle, taller than the side aisles, has a barrel vault constructed on a stone cornice which runs above the arches of the colonnades with stone intrados. Light would have originally entered the building from two symmetrical sides, but the windows on the left side were walled up in 1673 when the adjacent terrace, facing the Cloister of St Dominic, was roofed in.

The Library underwent extensive restoration in 1955 for an exhibition dedicated to Fra Angelico. The eighteenth-century bookshelves which were against the wall were removed as were the great walnut cases which had been constructed when San Marco became a museum to house the large collection of illuminated codices of varying dates which had come from numerous monasteries and convents in Florence and the surrounding area that had been suppressed. The codices, which number more than a hundred, are displayed in rotation, and kept in the adjoining Greek Rom (Sala Greca).

Michelozzo di Bartolomeo
The Library, XV sec.

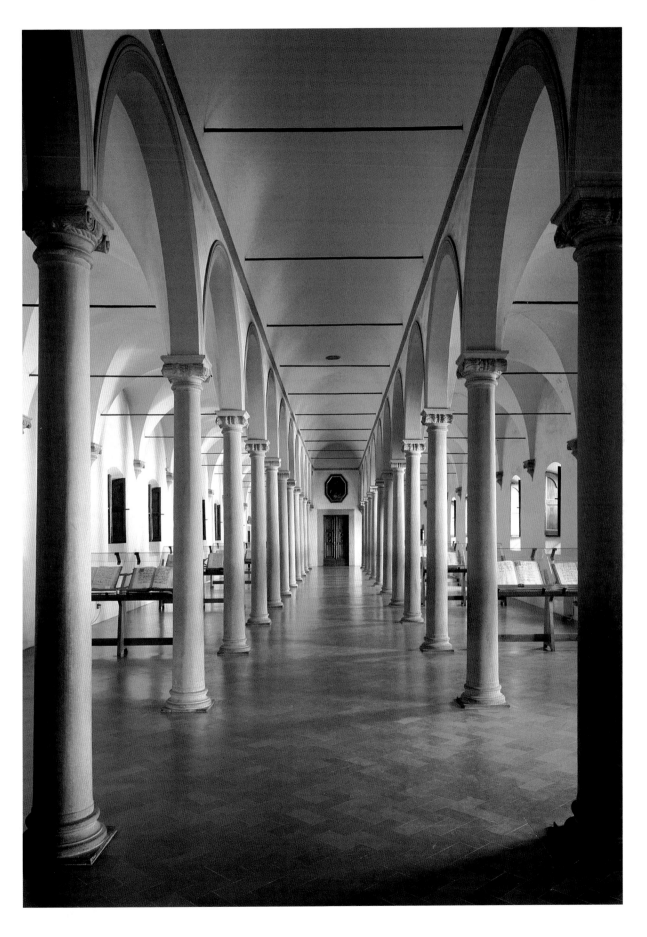

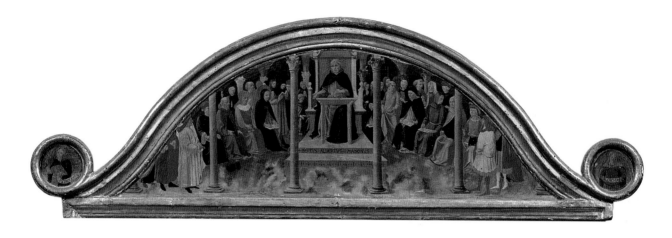

Zanobi Strozzi

Florence 1412–68

School of St Thomas Aquinas
School of Blessed Albertus Magnus

Panels, 47 x 150 cm
Inv. San Marco e Cenacoli, 1924 nos 8488, 8504

These two lunettes were originally hung in the theological wing of the Monastery. They are generally attributed to Zanobi Strozzi and date from the 1460s.

Gradual F

Membranous codex, 570 x 400 mm
Inv. San Marco e cenacoli, 1915, ms 561

Florentine Miniaturist

late thirteenth century

Nativity, initial P, c. 31v

Painting and gold-leaf on parchment, 120 x 100 mm

The oldest illuminated manuscripts in the San Marco Library are two graduals marked F and G respectively which originally came from the Monastery of San Jacopo di Ripoli and then passed into the ownership of Santa Maria Novella. The miniatures that decorate them are still tied to the Byzantine tradition which is most evident in the hieratical postures of certain scattered figures, but the calligraphy and the initials of the volumes seem to have already felt the influence of the more modern Bolognese miniaturist school and the innovations in late thirteenth-century Florentine painting. The decorations are of unusual refinement and suggestive beauty, helped by their perfect state of preservation. The initials, decorated with figures, are characterized by a colour range that juxtaposes strong hues, such as red lacquer and ultramarine, with lighter luminous colours, such as pink, and lifeless tones, such as pearly grey. In the infrequent scenes with figures, the miniature artist forces the rigid Byzantine stylemes to give visible form to intense, piteous expressiveness, as in the *Nativity*, reproduced here, where the passionate, agonizing embrace of the Virgin enveloping the infant Jesus is witnessed by silent, participating onlookers.

Antiphonary D

Membranous codex, 599 x 400 mm
Inv. San Marco e cenacoli, 1915, ms 564

Master of the Dominican Portraits

first half of the fourteenth century

The Perserverance of Job, initial S, c. 13v

Painting and gold leaf on parchment, 125 x 120 mm

This codex came from the Church of Santa Maria Novella, and it has a single figured initial attributed to the so-called Master of the Dominican Portraits, a painter who was remarkably prolific in the second quarter of the fourteenth century. The name that has been traditionally attached to him by the critics derives from a curious and interesting panel painted after 1336, also for Santa Maria Novella, which depicts an extensive and rare iconographical mustering of saints and holy men of the Dominican Order. The anonymous painter, who was influenced by the work of Bernardo Daddi and Jacopo del Casentino, unites exquisitely elegant formalism in the decorative elements with spirited expressiveness. The miniature illustrated here has refined decorations on the margins of the page with pastoral racemes interspersed with linear stars, contrasting with the perceptible eloquence of the scene where patient Job is set against other figures making extravagant gestures.

Antiphonary T

Membranous codex, 700 x 488 mm
Inv. San Marco e Cenacoli, ms 571

Don Simone Camaldolese

active 1381–1426

Nativity, initial H, c. 6r

Painting and gold leaf on parchment, 205 x 180 mm

The greatest number of fourteenth-century illuminated codices came from the Florentine Church of the Carmine. At least six of these came from the intensely productive so-called "School of Angels" and its most famous and prolific exponent, Don Simone, a Camaldolensian monk who originally came from Siena and who was a painter of miniatures for the Florentine Monastery of Santa Maria degli Angeli for many years, starting around 1370. Although of Sienese origin, he was a typical representative of the fourteenth-century Florentine school of miniature painting which developed page decoration with multi-coloured thick, undulating foliaceous vine shoots. Don Simone's work on the Carmine's choirbooks is attested by surviving documents; he proved to be a talented draughtsman who used a brilliant colour range that bears comparison with the best results of the more academic Orcagna workshop. Highly coloured fantastic birds nest in the large curling leaves that form spirals in the frieze; in the scenes with figures, depicted with a minimum of background, the figures celebrate the narrated event, rather than merely living it.

Missal D

Membranous codex, 590 x 400 mm
Inv. San Marco e Cenacoli, 1915, ms 570

Tuscan (?) Miniaturist

mid-fourteenth century

The Eucharist, initial C, c. 81v

Painting and gold leaf on parchment, 195 x 180 mm

Among the many liturgical codices kept in San Marco
that were originally from the Carmine, two missals,
including the one illustrated here and a Communion
of Saints, are highly unusual in the context of
fourteenth-century Florentine miniature painting.
Though they were illustrated by more than one artist,
the personality of one particular painter emerges: the
miniaturist who painted most of the initials. His style
was highly marked with broken, sometimes contorted
linearity. Scenes with figures and fantastic animals
were inserted into initials of complex iconographic
formation; rather like the Gothic *drôleries* typical of
cultures north of the Alps, but drawn with terrific
vivacity and in bright colours. An eloquent example is
the miniature reproduced here in which the painter,
animated by a kind of *horror vacui*, deforms the figures
grotesquely in order to fit them into the narrow space
of the initial letter. Current opinion tends to agree on
the existence of a single Scriptorium, probably in the
Pisan region, to which this expressionistic painter
was attached, along with another Master involved in
the decoration of this codex who was close to Traini
and the painter of the frescoes in the Camposanto
in Pisa.

Psalter H

Membranous codex, 470 x 310 mm
Inv. San Marco e Cenacoli, 1915, ms 559

Master of the Psalters

second half of the fourteenth century

*The Dream of Honorius III and St Dominic, holding up
the Church*, initial G, c. 298v

Painting and gold leaf on parchment, 125 x 125 mm

This psalter, together with another, came from Santa
Maria Novella. The hand of the same Master can be
discerned in both psalters, identified by some as Paolo
Soldini, author of the penwork in a codex belonging to
the Laurenziana (cod. 39) whose brushwork was
painted by Don Simone Camaldolese. However the
unlikelihood of finding confirmation for this hypothe-
sis makes it impossible to attribute the two San Marco
psalters to Soldini with any degree of certainty.

They are characterized by a colour range based on
strong hues, sometimes very dark colours, and by
accentuated expression in the figures, slight and elon-
gated when they appear isolated in the initial letter, or
sometimes depicted in groups with background details
minutely delineated. Ornamental vine-shoots along
the margin emanate from the friezes bordering the
initial letters, which, though still within the tradition
of Florentine miniature painting, are characterized by
smaller leaves that are more dynamically distributed.

Antiphonary

Membranous codex, 690 x 480 mm
Inv. San Marco e Cenacoli, 1915, ms 557

Bartolomeo di Fruosino

? 1366–Florence 1441

Pope Martin V consecrating the Church of St Egidio,
initial U, c. 61v

Painting and gold leaf on parchment

An important codex illuminated by Bartolomeo di
Fruosino in 1421, which came from the Ospedale di
Santa Maria Nuova, according to a declaration in the
colophon (c. 70). He may have been a pupil of Agnolo
Gaddi, with whom he worked on the frescoes in the
Duomo at Prato. He then collaborated with Lorenzo
Monaco (1370–1425) and worked with him on the
decoration of several codices. He was certainly
influenced by the latter, accentuating linear rhythms
and sometimes adopting a certain expressionism
which borders on the grotesque. However, Bartolomeo
di Fruosino distinguished himself with new spatial
settings, although they still lack rational definition.
This lustrous codex is especially important on account
of its high quality, the richness and dimensions of
the miniature paintings, and its useful documentary
notations, which help us understand the historic and
artistic development of the important Ospedale di
Santa Maria Nuova, where late-Gothic Florentine
miniature painting reached its zenith.

Psalter

Membranous codex, 385 x 267 mm
Inv. San Marco e Cenacoli, ms 531

Attributed to Fra Angelico and Workshop

Vicchio del Mugello *c.*1395–Rome 1455

King David with the Book of Psalms, initial D,
c. 169v

Painting and gold leaf on parchment, 90 x 90 mm

This psalter is almost a twin of another belonging to
the Museum. They both share the same illustrated
initials, with few variants, and both originated in the
Monastery of San Marco. In the past the miniatures,
with diminutive illustrations, were thought to be the
work of Zanobi Strozzi but recently their attribution to
Fra Angelico and his workshop has been preferred.
They belong to the late period of the artist's activity,
more or less at the same time as the doors of the Silver
Cabinet commissioned for the Basilica of Santissima
Annunziata. Some of the illustrations are of exception-
al quality, such as *King David with the Book of Psalms,* on
account of the elegance of the drawing, the choice of a
colour range dominated by rose-lilac, mauve and sky-
blue, the formation of the letters and the foliage,
dynamically articulated in concise, slender vine-shoots
in the friezes.

Gradual

Membranous codex, 475 x 345 mm
Inv. San Marco e Cenacoli, 1915, ms 558

Fra Angelico and Assistants

The Glory of St Dominic, initial I, c. 67v

Painting and gold leaf on parchment

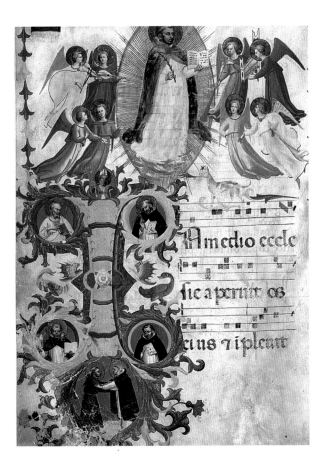

This missal is the richest and most precious text testifying to Fra Angelico's work as a miniature painter in his youth. It was, perhaps, painted for the Monastery of San Domenico at Fiesole at the end of the third decade of the fifteenth century. There are 30 miniature illustrations, of which the best 14 can be attributed to the Dominican artist. In these appear formal solutions and compositional notions which would, in essence, be taken up later in large-scale paintings.

The figures, shaped by a gentle moulding light, are arranged and intertwined among the initial letters forming friezes of cunning linear rhythms which have echoes of Ghiberti-style calligraphy. With great compositional freedom each letter is enriched and given life with spatial solutions that often depart from the accepted canon of the tradition of Florentine miniature painting. In the *Glory of St Dominic* Fra Angelico breaks the usual narrative scheme and, with an exceptional compositional *tour de force*, delivers the saint to a glory of musical angels whose colouring is bathed in light, and so demonstrates his absolute artistic maturity in achieving one of the most poetic and surprising pages of the entire codex.

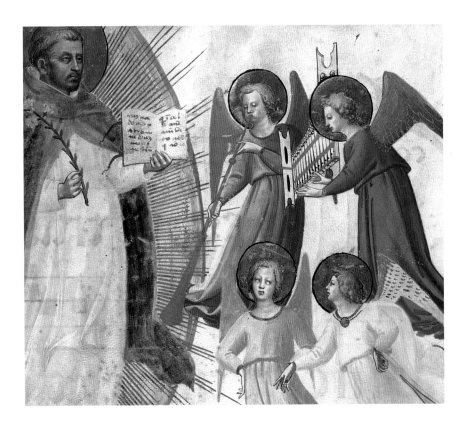

Gradual B

Membranous codex, 630 x 465 mm
Inv. San Marco e Cenacoli, 1915, ms 515

Zanobi Strozzi and Filippo di Matteo Torelli

The Calling of Peter and Andrew, initial D, c. 1r

Painting and gold leaf on parchment, 160 x 160 mm

As many as 25 codices originated in the Monastery of San Marco and, with one exception, all date from the fifteenth century. Of these, 11 have been attributed to Zanobi Strozzi, who illustrated them between 1446 and 1454 for Cosimo de' Medici, in collaboration with Filippo di Matteo Torelli, who painted the ornamental friezes. Fra Angelico's brother, Fra Benedetto, transcribed some of these codices, and the author of the alternating pen decorations in this codex was probably Fra Giovanni di Guido from the Monastery of Santa Croce. Zanobi was a prolific artist, according to documented sources, but he is best known for his work as a miniature painter. His manuscripts for the Monastery of San Marco comprise the core of his work and constitute the basis for an understanding of his artistic character. He was Fra Angelico's pupil as well as his collaborator, especially, perhaps, on the cycle of the San Marco Dormitory frescoes. In these, particularly in those that were painted in the final stages of decoration, an increasing stylistic affinity between the two artists can be seen, even though from an iconographic point of view many of the scenes and figures were influenced by analogous images found in Fra Angelico's Missal 558. Strozzi came closer to achieving a style of his own which diverged from Fra Angelico's by displaying a greater taste for the descriptive elements in the depicted narratives, by his skill in painting ample, flowing drapery and by using a

colder colour range characterized by the use of violaceous tones.

Manuscript 515 was the first in the series commissioned by Cosimo for the newly rebuilt Monastery of San Marco. The subject invites comparison with the same image by Fra Angelico in manuscript 558.

Communion of Saints

Membranous codex, 565 x 390 mm
Inv. San Marco e Cenacoli, 1915, ms 540

Attributed to Domenico Ghirlandaio

Florence 1449–94

and Workshop

St Andrew, initial M, c. 3r

Painting and gold leaf on parchment, 170 x 160 mm

This codex, together with Antiphonary no. 541, dated
1483, came to San Marco in 1867 from the Monastery
of Vallombrosa, whose crest is reproduced on several
pages. Recently the hand of Ghirlandaio and his work-
shop has been recognized on account of the many
similarities with the decorative patterns which the
artist adopted in larger works, both fresco and on
panel, typical of his busy *atelier*. This codex contains a
number of technical solutions not normally found in
miniature painting, such as sketching certain passages
or figures in the decoration, as in the page illustrated,
the painting on the lower half of the right-hand frieze
and the cherub on the right which mirrors exactly the
crest of the Del Caccia family who had commissioned
the codex.

Psalter P.S.

Membranous codex, 630 x 440 mm
Inv. San Marco e Cenacoli, 1915, ms 542

Monte di Giovanni

1448–1533

Consigning the Rule, initial L, c. 3r

Painting and gold leaf on parchment, 620 x 430 mm

This psalter, like Psalter 543, came from the Badia
Fiorentina, near the miniature painting and paper
workshop kept by Bartolomeo, Gherardo and Monte
di Giovanni. Monte, who by 1497 had become the sole
owner of the workshop, left numerous examples of
his skill in several codex cycles, most of which were
destined either for the Cathedral, or for the Church of
the Badia. For the Badia, as can be seen by the crests
inscribed on certain pages, Monte produced two
psalters, paid for in 1515, and now in San Marco.

Monte modified the relationship between decora-
tive margins and figures, which took on remarkable
substantiality, both plastic and chromatic, placing them
against a background of often sophisticated classical
architecture. Friezes were generally composed of linear
candelabra with classical undertones, or they became
proper frames with an illusionist thickness in which
apertures, or even windows, were interposed through
which jewel motifs could be seen.

The Greek Room (Sala Greca)

The Greek Room is normally closed to the public but is open on request to scholars. It derives its name from the fact that in the past valuable books in Greek were stored here. It is separated from the body of the main Library by an inlaid wooden door built in the eighteenth century at the same time as the massive cupboards in the four corners of the Library, housing the bulk of San Marco's collection of illuminated miniatures, were constructed. Majolica jars from the Monastery's ancient dispensary are also kept here, the sole surviving pieces of one of the few historic pharmacies. At one time, in Florence, monastic pharmacies had been numerous and remained in use until recently.

Majolica Jar

*c.*1570–80

Majolica, 32.1; max. diam. 23.5 cm
Inv.s.n.

By the late Middle Ages the Monastery of San Marco was probably already equipped with a dispensary where the monks concocted remedies with medicinal herbs for the benefit of their fellow monks. Like other dispensaries in Florence, such as the one attached to the other Dominican monastery, Santa Maria Novella, in due course it extended its practice beyond the needs of the monks themselves. They opened their doors to the general populace, competing with the commercial activity of the city hospitals and the town's ordinary chemist shops. It is likely that San Marco's monastic dispensary became a general pharmacy half way

through the fifteenth century, perhaps at the same time, as has been supposed recently, as the outbreak of plague in 1456. Then again, the existence in the Monastery of the Pilgrims' Hospice presupposes the presence within the compound of reception facilities to provide assistance to the poor and infirm. It can then be inferred that by the fifteenth century the pharmacy was equipped with its own supplies and the appropriate furnishings where medicinal substances could be stored, either in glass or ceramic containers, as well as the equipment necessary for the treatment of herbs.

There is no trace of this equipment, but a small number of supply jars have survived, many of them in the places for which they were destined. After the suppression of the monasteries in the nineteenth century not all the majolica jars were dispersed or removed by the Italian state, since a number of them were kept in use and were displayed by the still functioning monastic pharmacies; others can be seen in museums in Italy and abroad. Those that in 1916 came into the ownership of the embryonic San Marco Museum, as had others that had passed into state ownership in 1869, are kept in the large wooden cupboards in the Greek Room, until they can be properly put on display for the public. The collection comprises 25 majolica jars of Montelupo manufacture which were produced within a span of some 60 years, between 1570 and 1630, by an assortment of workshops.

This item is one of the oldest supply jars. It is characterized by green, yellow, orange and blue glaze, and a central garland contains a stylized "portrait" of St Antonino, a typical example of the strong, linear taste found in Montelupine manufacture.

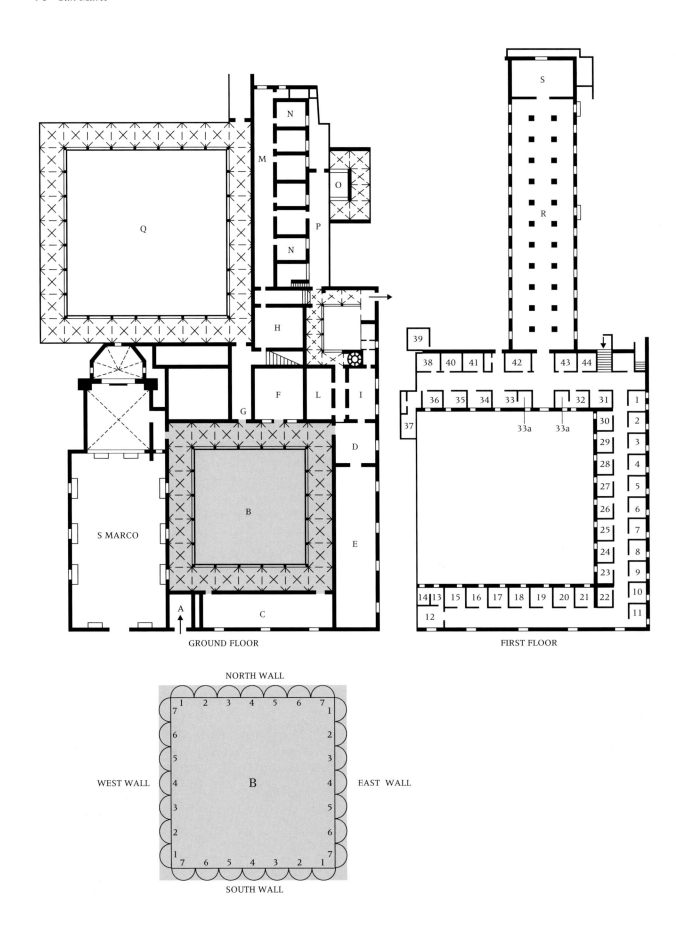

GROUND FLOOR

FIRST FLOOR

NORTH WALL

WEST WALL

B

EAST WALL

SOUTH WALL

Key to plan of the Museum and the Frescoes in the Cloister of St Antonino

Ground Floor
A Entrance hall
B Cloister of St Antonino
C Hospice hall
D Lavatorium hall
E Large Refectory
F Chapter house
G Corridor-bookshop
H Small Refectory
I Fra' Bartolomeo room
L Baldovinetti room
M-N Foresteria (Guest Quarters)
O Cloister of the Silvestrine Monks
P Granary court
Q Cloister of St Dominic

First Floor
R Library
S Greek room
1–43 Cells

East Wall
1. Beato Angelico *Christ in mercy*; Giovan Battista Vanni *Charity and Justice*
2. Bernardino Poccetti *The young Antonino adoring the Cross of Orsanmichele*
3. Bernardino Poccetti *The young Antonino dressed in the habit of the Dominican Order*
4. Lodovico Buti *St Antonino raises a young boy from the dead*
5. Alessandro Tiarini *St Antonino's Prophecy to a merchant*
6. Alessandro Tiarini *St Antonino at the restoration of the Church of San Marco*
7. Alessandro Tiarini *Pope Eugenius IV at the Consecration of the Church of San Marco*

South Wall
1. Beato Angelico *Christ received by two Dominicans* – Giovan Battista Vanni *Angels*
2. Bernardino Poccetti *St Antonino becomes Archbishop of Florence*
3. Lorenzo Cerrini *The Preaching of St Antonino*
4. Bernardino Poccetti (attr.) *St Antonino rescues the canon Machiavelli from drowning*
5. Michele Ciganelli *St Antonino establishes the Confraternity of the Buonomini*
6. Beato Angelico *St Thomas Aquinas*; Giovan Battista Vanni *The Miracle of the Key found in the Belly of a Fish*

West Wall
1. Fabrizio Boschi *St Antonino eschews a wife's curiosity*
2. Bernardino Poccetti *St Antonino rescues two young men from drowning*
3. Bernardino Poccetti *St Antonino cools the metal in a foundry*
4. Lorenzo Cerrini *St Antonino absolves the eight Balia*
5. Sigismondo Coccapani *St Antonino unmasks two fraudulent beggars*
6. Fabrizio Boschi *St Antonino overturns a gaming table*
7. Beato Angelico *St Peter martyr beckons for silence*; Giovan Battista Vanni *Faith and Hope*

North Wall
1. Beato Angelico *Christ on the Cross adored by St Dominic*; Cecco Bravo *Mourners and Angels*
2. Bernardino Poccetti *St Antonino on a mission from the Pontiff*
3. Bernardino Poccetti *The Miracle of fertility*
4. Pier Dandini *St Antonino gives spiritual succour to victims of the plague*
5. Beato Angelico *St Domenico with the discipline and the rule*
6. Pier Dandini *St Antonino talks to a greedy farmer*
7. Matteo Rosselli *The Death of St Antonino*

Bibliography pertaining to the San Marco Museum, Florence

M. Scudieri, M. Sframeli, *Il vecchio centro di Firenze e le sue 'relique'* (Florence, 1990)

M. Scudieri & M. Sframeli, *Le 'pietre' di San Pancrazio* (Florence, 1990)

La chiesa e il convento di San Marco a Firenze, AA.VV. 1 & 2 (Florence, 1990)

G. Damiani, L. Marchetti & M. Scudieri, *Rinvenimenti e restauri nel complesso monumentale di San Marco* (Florence, 1993)

M. Scudieri, *San Marco. Guida completa al Museo e alla chiesa* (Florence, 1995)

Fra' Bartolomeo e la scuola di San Marco, exh. cat., curated by S. Padovani in collaboration with G. Damiani and M. Scudieri (Venice, 1996)

Index

Page numbers in italics refer to illustrations